THE BUSINESS OF ILLUSTRATION

THE BUSINESS OF ILLUSTRATION

STEVEN HELLER & TERESA FERNANDES

DESIGNER: TERESA FERNANDES

ART ASSOCIATE: DANIEL DRENNAN

ASSISTANT EDITOR: JOHN HASSAN

RESEARCHER: COURTENAY CLINTON

WATSON-GUPTILL PUBLICATIONS/NEW YORK

Senior Editor: Candace Raney
Associate Editor: Micaela Porta
Designer: Teresa Fernandes
Art Associate: Daniel Drennan
Photographer: James Koch
Assistant Editor: John Hassan
Research: Courtenay Clinton,
Karen Mynatt, and Jessica
Hartshorn
Production Manager: Hector
Campbell
Cover and Chapter Illustrations:
Jeffrey Fisher

This book was created in
a digital environment using
Carmella and the Didot
font family.

First published in 1995 by Wat-
son-Guptill Publications, a divi-
sion of BPI Communications,
Inc., 1515 Broadway, New York,
NY 10036.
Library of Congress
Cataloging-in-Publication Data
Heller, Steven.
 The business of illustration/
Steven Heller & Teresa Fernan-
des; designer, Teresa Fernandes;
art associate, Daniel Drennan;
assistant editor, John Hassan;
researcher, Courtenay Clinton.
 p. cm.
 Includes index.
 ISBN 0-8230-0545-3
(paper): $27.50
 1. Commercial art—Econom-
ic aspects—Handbooks, manuals,
etc. 2. Commercial art—Prac-
tice—Handbooks, manuals, etc.
I. Fernandes, Teresa. II. Clinton,
Courtenay. III. Hassan, John.
IV Title.
NC1001.6.H45 1995
741.6'068—dc20
95-3050 CIP

Distributed in the United
Kingdom by Phaidon Press,
Ltd., 140 Kensington Church
Street, London W8 4BN, Eng-
land. Distributed in Europe
(except the United Kingdom),
South and Central America, the
Caribbean, the Far East, the
Southeast, and Central Asia by
Rotovision S.A., Route Suisse 9,
CH-1295 Mies, Switzerland.
Manufactured in Singapore.
First printing, 1995
1 2 3 4 5 6 7 8 9 /02 01 00 99 98
97 96 95

The authors are indebted to Courtenay Clinton and John Hassan for their editorial assistance, James Koch for his photographs, and Daniel Drennan for his production expertise. Heartfelt thanks go to Candace Raney, senior editor, and Micaela Porta, associate editor, at Watson-Guptill for their invaluable help in the preparation of the manuscript. Thanks to the scores of illustrators, too numerous to name but included in this volume, who have donated their time, energy and work, as well as those who generously provided insight and information which, owing to space constrictions, are not represented here. Also our gratitude to artists' representatives Richard Solomon, Vicki Morgan and Fran Seigel for their agreeing to be interviewed. And a special tip of the hat to Jeffrey Fisher whose cover expresses in one image the thousands of words in this book. —SH & TF

Table of Contents

The Business of Illustration Is Business

Illustration is a commercial art that requires not only technical and aesthetic expertise, but a savvy business sense. But readers of this book are not illustrators because of a secret desire to practice business; making art, even in a commercial arena, is the prime motivation. Making a living from that art may be the goal, but I reckon that the thought of becoming a salesperson or bookkeeper is not the uppermost concern. However, if one is really intent on getting work as a professional illustrator a cold, hard fact must be faced: One cannot hope to succeed these days without a modicum of business acumen. I refer not to efficient billing systems, but the kinds of business skills that enable one to *sell* one's talents over time. Viability in the market depends on having an edge. With today's illustration field so agressively competitive the wannabe, neophyte and even many veterans need to know as much about marketing as any wholesaler or retailer.

Don't worry, though, this will not interfere with making art, but will enable one to make more of it, preferably at a profit.

The main thing one needs to know is that illustration is not for dilettantes; it is a business and a potentially lucrative one. The financial rewards can be good, but the total riches are enormous if you factor in the indeterminables like satisfaction and pride in one's creative output. As a business, however, illustration is subject to Darwinian principles. The fittest, and not necessarily the most talented, survive. Given the large number of undergraduate, post-graduate and continuing education programs in the United States alone—reportedly over one thousand—there is no dearth of potential talent. Add to that those schooled abroad and the talent pool feeds into an ocean. Those who have a clear sense of how they fit or where they want to position themselves in the field are at least one stroke ahead of those who enter not knowing how to swim.

The problem is that most illustration programs fail to prepare their students for the realities of professional life. While they stress drafting and conceptual acuity as well as portfolio presentation and content, they never even touch on the fact that a smartly edited portfolio is merely the key to a labyrinthian world of illustration that offers more deadends than pathways. For every illustration job there are scores of aspirants. More than half of the neophytes who get that first, second, or even third job will probably not get many more. Without a certain business know-how the chance for survival is perilously reduced. And yet while attrition is high, there are various options for survival.

While an illustrator might find one of the safe havens on the border between creativity and drudgery, there is no point in seriously becoming an illustrator unless one is willing to accept greater challenges. Simply surviving is not an optimum state. The ability to navigate around or through professional obstacles and barriers is necessary if one wants to forge a meaningful illustration career. At the same time an illustrator must somehow find a greater state of fulfillment. This is determined to a large extent by one's ability to cope with both the constraints and vagaries of business. Whatever it takes to be fulfilled—earning good fees, getting challenging assignments, or achieving high visibility—it will only come if a measure of business sophistication is brought to bear. One might survive with a few regularly paying clients, but real fulfillment comes when goals that are put forth at the beginning of one's career are later realized by having made smart business decisions.

If all this talk about business is daunting or depressing, remember that no one is suggesting that an illustrator become a financier. The business of illustration has two distinct sides: One is the day-to-day management of one's worklife, such as accounts payable and receivable, rent, insurance and cashflow; the other is the propagation of one's talents through self-promotion and salesmanship. While the former is pretty much determined by practical and standard practices (indeed, one can hire experts to handle such things), the latter is more subjective. To maintain a competitive edge self-promotion and salesmanship must differ between different practitioners. Although tempting, one cannot simply follow the pack. What is useful to one may be superfluous to another. There are very few hardfast rules on this side of the business but there are a variety of alternatives.

This book will not address the day-to-day management of an illustration studio other than to make the common sense suggestion that an accountant or business manager who offers sound financial advice is a good idea both professionally and personally. On the other hand, this book will focus on creative business options and strategies aimed at increasing one's level of professionalism, a word that is often misinterpreted to imply "conservative" or "unimaginative." Being professional does not mean succumbing to the bugaboos of adult life that often force one to become an artist in the first place. Instead, being professional means having a mature attitude that elicits the respect of clients.

Too often illustrators suffer from a lack of respect because, as artists, they are perceived as a little off-balance to start with. While some may choose to cultivate this persona, the majority of illustrators are not chronically weird. Yet many do lack the business and sometimes social skills

The Entrepreneurial Artist

Illustrators should think of themselves as entrepreneurs, not freelancers. "Freelancer" is a passive hand-for-hire term, while seeing illustration as a small business means taking an active role. You need capital to start; you need a business plan; you need to figure out what market you can fill; and you need to advertise. Most businesses take three to five years to turn a profit, yet many illustrators become discouraged if they can't live off their work after the first year.
—Julia Gran

necessary to match wits with their clients or potential clients. Hence, professionalism is not some kind of rigid, imposed behavior modification, but a learned or acquired competence that can be designed to fit the individual. One should manage one's business with the kind of forethought and thoughtfulness that runs the gamut from simple common sense, such as delivering jobs on time, to creative strategy, such as developing a well orchestrated self-promotional campaign.

But this is not a how-to book about self-promotion or creating the "winning" portfolio—various fine books and magazines have already covered that territory. Rather, this book will explore what is needed to develop a business sense by using a variety of available tools that include, but are not exclusive to, self-promotion and building a portfolio. An even more fundamental survey of approaches

Loyalty Pays

While it is important, both creatively and financially, to find new clients, don't neglect existing ones. I strive to keep them as excited about my work as I can. And I never take them for granted. It is far easier to cultivate these proven relationships than to start from scratch to establish new ones. Ultimately, these relationships tend to yield the kind of work that attracts new clients.
—Michael Klein

helps the wannabe or neophyte illustrator acquire knowledge about the field as a whole, such as understanding the different genres of illustration—editorial, advertising, book publishing, technical and so forth. For before one can promote or assemble a portfolio it is important to focus one's energy and talent on a goal.

For example, an artist who is incapable of developing the sharp, conceptual ideas needed for magazine or newspaper spots, but who has great technique may be better off in advertising, book, or another more decorative illustration genre. Knowing how best to use one's strengths should be a matter of common sense, and yet it is surprising how few illustrators know how to do it. In fact, common sense is really only one part of the equation. Knowing how to access support systems is also a must since few, if any, illustration programs have courses in representation. Knowing how to select an artist's rep or the corollary, what it takes to get a rep interested in you, are lessons that illustrators should not have to acquire by osmosis.

Although business strategies based on specific goals do not guarantee success, they do increase the possibilities in this competitive field. The more one understands the options the fewer wrong decisions are made and the less frustration there is in starting one's career. It is in this sense that *The Business of Illustration* is designed to be a straightforward survey, analysis, and examination of what is necessary to launch and maintain an illustration career. The expertise of various veteran artists, art directors, designers, art buyers and artist representatives is drawn upon to give the reader every chance to enter a decidedly difficult, but rewarding field. To paraphrase a well-known New York clothing store advertising motto, an educated artist is a smart illustrator. And a smart illustrator will only benefit from being savvy in the art of commerce.

Lifestyle and Business

Illustration in many ways is a unique business to be in. We illustrators get to use our talent to create and maintain lifestyles; to do what we love and get paid for it. We get to avoid the corporate world of homogenous suits and haircuts while very often making more income than those to whom we cater. But illustration is a business. And like every other business, as much emotion can come from a cash flow crisis as from an over-night deadline for *Forbes*.
—Dave Cutler

What They Do and Don't Teach in School

Some argue that drawing is the only thing that an illustrator needs to learn. Don't believe it. Of course, as the primary tool for both communication and expression drawing must be totally mastered, but it is not an end in itself. Just as important, an illustrator must learn how to *think*— how to develop thoughts into ideas, ideas into concepts and concepts into messages. An illustrator needs to be fluent in verbal language in order to translate word into image to form the proverbial picture that speaks a thousand words. Some say that this is the job of an art school, yet while some art schools massage the mind, most are devoted to teaching skills. Although skill-based education should not be scoffed at, an illustrator requires a good liberal arts education, too. Arguably, liberal arts should come first.

Often young artists go directly from high school to art school. There are some compelling reasons for this, which have more to do with following the muse than with common sense, but these students are nevertheless often too hasty for they do not allow time enough to examine more inclusive educational programs. The muse, though commanding, is undisciplined. It needs harnessing in the same way that innate talent needs cultivation and nourishment. It needs to be informed by wisdom that most young people have yet to acquire. Art school is the place where intuition meets knowledge and where aptitude is bolstered by skill, but it is often a hermetically sealed environment concentrated on a limited course of study. At most art schools, despite the requisite nod to the liberal arts, the student is not exposed to or encouraged to take part in classes about literature, sociology, psychology, or history. The liberal arts are often dismissed as electives.

Having a liberal education will not necessarily guarantee a rosy illustration career, but neither will an art school education. What liberal arts *will* facilitate is a better understanding of subjects and themes that an illustrator will encounter in a majority of assignments. A familiarity with literature, for example, provides the artist with centuries of metaphor,

allegory, and symbol, which when translated into imagery is the foundation for strong visual ideas. A grasp of history provides a foundation of social, cultural and political knowledge that frequently will arise in illustration briefs. Sociology, psychology and other human sciences also bolster the conceptual basis for much illustration. Without these tools an artist can make aesthetically pleasing pictures —even occasional extraordinary ones— but being visually literate is not simply a matter of turning a circle, square and cone into a cat or dog, but assimilating, synthesizing and translating human knowledge and experience into visual terms. The most effective illustrators have not simply mastered skill or developed style, but have eloquently used symbol and metaphor in their work.

For the vast majority of young illustrators art school, and to a lesser extent, postgraduate degree programs, are the primary or perhaps the only formal education they will receive. Though current statistics show a significant increase in the number of students who remain in school for longer than the average four-year undergraduate stint and then matriculate through degree programs before entering the "real world," this is not true of illustration students. The illustration field does not require that practitioners have advanced or continuing education degrees, or any degree for that matter. A portfolio, not a resume, is the determining factor for getting work, and yet there is a crying need for illustrators who with broader interests are not merely art specialists. The well trained *and* well read artists will surely enjoy greater benefits than those with a narrow focus.

Advancing Education

FOR MORE THAN HALF A CENTURY Master of Fine Arts (MFA) degrees have been available to students of painting and sculpture. Twenty years ago the idea that an MFA would be given for illustration was unthinkable. Since then changes in educational programming and student demographics have resulted in degrees dedicated to various forms of illustration, notably at programs supported by Syracuse University and The School of Visual Arts, New York. The reasons vary: More fine art aspirants are turning to commercial art to make their livings; commercial artists have become more interested in increasing their scope as communicators; and no less significant, the apparent increased need for illustration teachers at college and university levels require that faculty have advanced degrees. Generally artists who have liberal arts and/or art school education will find that advanced degree programs provide further opportunity to learn more about the nuance and history of the craft. But more importantly, the best of these courses help to develop *intellectual* skills.

Degree programs have traditionally provided the student a hiatus before entering the work force. For those already itching to do professional work these programs also allow a smooth transition from one rigor to the next. The often frustrating job hunt is less threatening when one has the security of still being in school. But perhaps the most common reason for entering a postgraduate program is that they afford—indeed, encourage—opportunities for research and development: Testing convention, pushing boundaries

and experimenting with form and content free from marketplace constraints offers a student the chance to explore inner motives and personal voices with certain controls. The hot house environment requires that work be subjected to formal critique. In fact, the measure of a good program may very well be determined by the vigorousness of its criticism. Not all experimentation is successful (nor should it be) and both self- and outside critical controls give the student valuable perspective.

A good reason for choosing an advanced education program is therefore to be part of a controlled environment that helps one realize one's strengths and weaknesses. In a field as competitive as illustration attaining proficiency in one's area of potency is imperative. Good postgraduate programs usually are small enough to afford individual tutorials. They encourage pushing the limits of perceived capability, but also see to it that the student does not overstep the bounds of competency. The graduate experience at once allows the student to play around with various forms while discouraging unrealistic approaches that might prove to be an impediment in getting sustained work after school is finished.

Should all aspiring illustrators enter degree programs? The answer is no. Many students are as prepared as they will ever be to proceed straight from art school to the profession depending on their talents and initiative, based, of course, on the overall quality of the undergraduate program itself. The undergraduate who has mastered form, developed style and is fluent in one or another conceptual languages will do just fine if lucky enough to find steady work. For example, an exceedingly high percentage of graduates, seniors and even some juniors in the undergraduate illustration department at The Art Center College in Pasadena, California, are remarkably well equipped to do professional editorial work. Contributing to the

high level of one school's competency is a combination of rigorous drawing, concept and ultimately portfolio classes deliberately geared toward professional placement. It helps, too, that the director, Phil Hayes, has a solid grasp of what viable editorial illustration should be. Art Center's expressionistic, concept-based approach to

teaching is consistent with current trends, yet it encourages students to extend the boundaries and transcend the fashions. Conversely, a less focused undergraduate program—one that stresses more general approaches—may not prepare students well enough to enter the professional ranks. In this case a postgraduate program can be exceedingly useful.

These programs can also be exceedingly expensive. Although scholarships are available to students applying to most postgraduate programs, only a small percentage of students are eligible for the available funds. Generally, it is difficult to measure the cost of an education against one's potential fulfillment, but the illustrator hopeful who enters a postgraduate school should be aware that it is unlikely that the cost of education will be recouped immediately. While the monetary gains of studying for a profession are more or less quantifiable by recognized average salary ranges within specific professions (i.e., law,

School catalogs. Clockwise: School of Visual Arts, Savannah, California College of Arts and Crafts, The Cooper Union for the Advancement of Science and Art, Art Institute of Boston, Art Center College of Design, Syracuse University, School of Visual Arts, Art Center College of Design at Night.

CHANGING STYLE

EVERY ILLUSTRATOR HAS A STYLE. For some, style is their personality and changing it would be like undergoing behavior modification. Yet for others style is as easily removed as an overcoat.

Having one (or more) style(s) is endemic to the business of illustration. It can attract like honey to Pooh Bear, or repel like a cross before the vampire. Style is what the client sees first; the signboard that says "hire me." It is therefore one of the illustrator's most valuable assets.

So what possesses an illustrator to change a style?

A young illustrator will probably try many styles before deciding upon one (or two), and some of those styles may actually belong to others. But eventually the young illustrator will find the graphic "voice" that fits—at least for a while.

Garnett Henderson not only changed his style from watercolor to collage but his name became Edmund Guy.

Over the course of time a veteran may find his or her too constricting and therefore decide to experiment with others. For example, Brad Holland adopted various styles over his thirty year career. In his early days as a *New York Times* OpEd Page contributor his work evolved from the cartoon-like expressionism of Robert Crumb to the linear virtuosity of Goya. Holland acknowledges an early debt to Goya's prints, as well as to drawings by Leonard Baskin, Ben Shahn, and Kathe Kollwitz. His black and white drawings from the late 1970s exhibit the influence of all three. Later when he became more of a colorist, Edward Hopper played a significant role. But as he absorbed the influences of these models, he also developed his own distinctive visual persona. Nevertheless, despite the success he has had with certain styles he continues to allow his art time to develop. For Holland, style is a skin that he sheds to reveal yet another skin.

Philippe Weisbecker also began his career in the late 1960s with a cartoon-like style that evolved into one that echoed the linear surrealism of French satirist Roland Topor. Weisbecker used this method to render conceptual illustration, which though proved successful, was never truly his own style. After exposure to nineteenth-century French Epinal prints he began to develop a spare linearity combined with small fields of flat color. The approach grew into a signature style that brought him lots of work for editorial and advertising markets. But after a few years even this began to develop into the more roughly hewn, abstract style that he works in today. These shifts were responses to his need to find more artistic satisfaction, whether it worked for his clients or not.

Which raises the most important issue of style changing. When illustrators alter styles their clients are forced to readjust their expectations. A new style can either be a success or failure depending on how it is received by clients. Yet while some old clients might reject a new approach, conversely newer clients might warm to it. There is always a trade-off.

So an illustrator should know when to change. If his or her career is just beginning the so-called marketable style should be maintained at least until an illustrator's track record is established. Then, perhaps, the best thing to do is experiment. Show the new style to art directors to get a reading of the market. Or do what Guy Billout and Garnett Henderson did: Take out separate advertisements (under psuedonyms) introducing their new styles. In Henderson's case, under his alter ego Edmund Guy, a newer collage style attracted many more interesting jobs than his older painterly approach. Henderson was dissatisfied with old method and needed to try another. So for those illustrators who are not doing as well, or are not as fulfilled as they would like, changing style can be accomplished whenever one is ready.

medicine, engineering and the like), the illustration business offers few if any financial signposts. Job fees range from the low two to the high five figures and are often arbitrarily determined by the client based on the scope of a project. Depending on talent (and luck) a graduate can earn either a lot or a little upon leaving school. With the right breaks the indefatigable young illustrator can start a meteoric rise. But for every postgraduate's success scores of others will invariably struggle from job to job—sometimes for an intolerably long time.

Graduate school cannot guarantee anything other than two years of intense work. Of course, one hopes a distinctive portfolio will be the result, but the student must know from the outset that an advanced education is not a magic pill which, taken in large enough quantities, will cure the ails of the struggling artist. If full advantage is taken, however, it will increase performance to a level that insures proficiency, which is the first step toward attaining a satisfying career.

Starting at the Beginning

A SIMILAR CAUTION SHOULD BE ISsued for undergraduate students. While taking illustration courses will benefit the student who has no knowledge of the field it does not provide all the answers. Only experience can do that. But some undergraduate schools are better than others, owing to, say, a faculty made up of practicing illustrators versus one of only full-time teachers; or, given the rise in computers, a low- versus high-tech curriculum.

What distinguishes one undergraduate program from another also has a lot to do with overall teaching philosophy. Most illustration programs offer the same fundamental skill- and concept-based classes. Although some schools might differ as to whether skill/craft is more important than

idea/concept, in the final analysis the quality of teaching itself is the deciding factor. Without motivated teachers there can be little chance for motivated students. Regardless of philosophical, ideological, or practical points of view, a good teacher will provide a good role model. Uninspired teachers will beget uninspired students. All things being equal, however, the goal of an illustration program is to prepare students to enter the profession. Within the three- or four-year course of study a competent program will emphasize drawing and painting, media (pen and ink, watercolor, woodcut, oil, computer, etc.), form (editorial, technical, book illustration), content (meaning, story), problem solving (allegory, metaphor, symbolism) and ultimately the portfolio. Upon graduation a student should be able to draw or paint more or less proficiently, conceptualize intelligently and have a portfolio that highlights these abilities.

Conversely, an undergraduate illustration program will not teach talent. If it wasn't there to begin with, it will never be. What a program can do, however, is help the student recognize that there are levels of talent that can be exercised and nurtured. It is important to recognize that some artists are better than others for a variety of reasons, having as much to do with indeterminables, such as innate ability, as with determinables, such as knowledge and experience. A competent undergraduate program will attempt to bring out the best in students given their range of talents. Nevertheless, some students simply may not have what it takes to succeed. Not everyone who can draw should be an illustrator. Likewise, not

everyone who can visually conceptualize can be a illustrator, either. While an illustrator is always an artist, not all artists are illustrators and not all students who fancy themselves to be artists are so endowed. Some illustration programs force square pegs into round holes, or worse, they allow students who show minimal ability to graduate because they've fulfilled certain standard requirements, not because they excel at this difficult art form.

What They Don't Teach in School Could Fill Volumes

ENTRANCE STANDARDS TO MOST undergraduate programs require that a young applicant show only the most rudimentary skills. Though not as simple as the "draw me" matchbooks, based on common entrance exams one might get the impression that the art business, and in particular the illustration business, is pretty easy. Nothing could be farther from the truth. Making good art is difficult and becoming a good illustrator requires considerable hard work and dedication. Nonetheless art schools tend to minimize the effort required, perhaps to elicit their quota of bright-eyed young students. Very simply, the truth is not always taught in art school. What is unspoken could fill volumes with valuable information that might dissuade the marginal talents from entering the fray and frittering away valuable time and energy.

The process of weeding out the good from the marginal students once they're in art school purports to be Darwinian. In fact, most schools tacitly reject natural selection. Student recruiters lean toward giving students the benefit of the doubt. If one merely shows aptitude the odds of acceptance are high. But aptitude does not always pan out, resulting in disappointment. Students are nevertheless often encouraged to continue through the first year's introductory foundation courses which try to bolster skills before they enter more dedicated courses of study. Few ever fail foundation, and even poor renderers are invariably matriculated and then forced, as it were, to survive among the fittest.

It has been argued that illustration is in many cases merely an entry point for those who want to be in an art-related field but are concerned about the quixotic future of the fine arts. Commercial art has more financial viability, if not stability. So for those unaware of art-based disciplines illustration seems close to fine art. For those who are unable to handle illustration over the long haul, the fundamentals imparted in these programs at least serve as a good basis for working in other fields, such as graphic design, typography and advertising. On average less than sixty percent of all students continue in illustration programs through to graduation.

But for the ones who do finish an entire program the illustration field is rarely fully explained. Most educational programs emphasize the art and craft of illustration and only give lip service to, or entirely ignore, the *business* of illustration—the tools that will allow the "fittest" to forge viable careers. The most business-related course of study offered in art school is probably the portfolio class, which is responsible for developing the student's credentials. Even more than self-promotion, the portfolio is a veritable signboard that telegraphs to a prospective client the respective merits of the artist (see chapter 5). Without a viable portfolio that exhibits skill, imagination and vision the artist is essentially invisible. So the most important business instruction that a school can

Experimental What?

At the Ontario College of Art I studied Experimental Art, which is essentially a fine art program with an emphasis on late-20th century art. I spent the last two of my four years in the OCA's off-campus program in New York. In all my time at college I attended no illustration or desgin courses. While that probably isn't the logical route, it did expose me to a broader and more varied range of experiences than I would likely have encountered in a mainstream illustration program.
—Frank Viva

offer is how to edit a portfolio to make it into a salable sample case.

This should not, however, end an art school's responsibility to its students. Art schools should impart lessons in conventional operating procedures. Neither drawing nor conceptualizing is enough to make an illustrator whole, nevertheless art schools do a miserable job of preparing students to survive in and out of their studios. Few, if any schools provide courses in studio management, which implies a range of activity from what furniture and supplies to buy, to what accounting and bookkeeping procedures to follow, to which options for self-promotion are realistic. Rarely do schools prepare students to actually meet with art directors or art buyers, shop around for agents or reps, or cope with difficult clients. They do not teach students the implications of doing spec (or free) work, how to prepare a purchase order or contract, or demand kill or sketch fees. In a field where clients sometimes take advantage of artists, knowing the tips for survival are imperative. However, with the exception of ad hoc advice from veteran teachers, too many unsuspecting students are sent blithely into the world like Red Riding Hoods with their portfolios of goodies, where instead of kindly grandmas they meet hungry wolves. Even if in reality the overwhelming majority of art directors, art buyers, and clients are not ravaging carnivores, they can certainly appear imposing and menacing to the neophyte who is untutored in the standard operating procedure (see chapter 2).

By not revealing or simply ignoring all the facts about the business of illustration, an art school is not doing its job. Since this is generally the case, before graduating—in fact, as a condition of attaining professional status—a young artist should seek out information from teachers, other professionals and friends about what awaits him or her in the marketplace and how to deal with it.

Continuing Education

GRADUATION FROM ART SCHOOL OR a postgraduate program is not the end, but the beginning. Education should not be a limited experience confined only to an academy or institution. The process continues throughout a career, especially with all the new advances in technology that continue to alter the fundamental practice of illustration. Therefore, it makes good sense to keep adding to the store of knowledge by keeping abreast of and experiencing new developments while refreshing old skills. Continuing education is one way to keep in touch with the shifts in practice. For the illustrator wannabe or neophyte this kind of course work in a variety of subjects, including portfolio editing, visual conceptualizing and computer art, is a good way to further build necessary skills. Those who have never gone to art school will find that the better continuing education programs offer a way to avoid lengthy undergraduate or postgraduate timetables. Even for those with limited experience an additional course is certainly beneficial.

Regardless of one's level of expertise, most continuing education formats are geared exclusively to people who want to either immediately enter or improve their standing in the profession. In addition to intensive extracurricular coursework, these programs also allow students to network with other artists and professionals. The majority of programs employ faculties of experienced professionals which provide students with first-hand information about the field. Many also employ guest lecturers whose experience can be invaluable to the student. Teachers often bring their own assignments into class and invite students to help solve their illustration problems, which are then critiqued according to professional standards. If the teacher's art director or art buyer is willing, class assignments might be even be

Card pack. Illustration students from Parsons in New York exhibit their talents in school sponsored card portfolios.

SHOULD STUDENTS WORK PROFESSIONALLY?

STUDENT PORTFOLIOS are expected to change and grow over time. A truly professional portfolio is built little by little, with each job a brick in the construction of a career. One of the most prudent ways to start the building process is by getting as many respectable small jobs as possible. Although some students might be lucky enough to find a job or two in a major outlet, the majority of initial jobs will be found at small concerns often based in the artist's locale.

Students who want to try their hand at getting real work should identify all the potential illustration buyers in their particular locales, such as small publishers (i.e., poetry or literary magazines, town or village newspapers, pennysavers and other print advertising vehicles) or merchants with special illustration needs. Make a list, send a promotional card, or better yet, make appointments to see them. Small concerns are infinitely more open to face- to- face interviews than large ones. If it's a publisher, the editor or art director should be contacted by mail or phone for an appointment. In the case of local merchants, a blind call or unannounced visit might prove effective. If one is lucky enough to be paid a small commission, the fees may be low but the potential exposure is worth it. If the job is fairly creative, it could result in a good portfolio piece.

outside world. However, if a student's portfolio is good enough to land a professional job, why not go for it? The potential for acquiring experience could easily equal what can be learned from a year's worth of school projects.

Students who slowly start looking for work in, say, their

NOZONE and *The Progressive* are two of many magazines that offer a certain amount of freedom, while at the same time imposing certain professional limitations. As such they are good training grounds for students.

Teachers are often conflicted about whether or not students should do professional work. Some believe that the portfolio should be top notch before attempting to present it outside of school. Moreover, they feel a student should devote all his or her time to class projects that will better prepare one for the

junior or senior years are actually beginning a process that they will have to start eventually. Why not start it sooner than later? The chance to get a couple of professional portfolio pieces will increase the likelihood of getting more work later. Even if a job is not forthcoming, outside feedback is invaluable.

selected for publication.

Continuing education courses are highly effective, short-term ways of imparting knowledge and skill. Students are not required to follow rigid formal programs and can take any number of classes as needed. But not all classes are equal and not all teachers are exemplars. Before deciding to register, the catalog course descriptions and teacher biographies should be studied carefully. Sometimes a clever course title like, "Exposing Your Guts on Paper" or "Making Millions on Your Ideas" might sound sexy but are superficial. A student should decide what is needed from a course, and then find the appropriate description. If one wants to become more proficient at collage, life study, or concept those courses will usually be clearly defined. The School of Visual Arts in New York, like other better continuing education facilities, offer a wide range of introductory, intermediary and advanced classes. Some require the presentation of portfolio before being admitted, others do not. Hence prospective students should be certain that they are equipped to handle the classes.

For crossovers from other art or design fields, of which there are many, continuing education programs can be a veritable smorgasbord from which to sample the skills and disciplines needed before entering a new profession. Before entering one should get counsel from experienced professionals about which teachers to look for and what classes to take. There can be nothing worse for someone just testing the waters to fall into the wrong program.

Education versus Experience

EXPERIENCE IS THE BEST EDUCATION. However, formal education offers the fundamentals that may take years of experience to learn. Not all illustrators went to art school, but these days it is hard to find an artist without some degree of training. And frankly, given the large number of artists who are seeking out illustration work it is becoming increasingly beneficial to have an education that defines the various illustration genres and how to prepare a portfolio that addresses them.

Whether an artist opts to attend a college, university, art school undergraduate or postgraduate program is a personal decision that needs to be based on a realistic evaluation of one's capabilities and desires. Whether the program is full-time or continuing education will be determined by individual need. There is no right way to enter the illustration field, but there are wrong ways, like doing it blindly. Taking the experiential route without benefit of any of the formal guidelines that an education provides will invariably mean muddling through, learning from a bevy of mistakes, if learning at all. Even a rudimentary art school education will prepare one for the experiences to follow. But having an education is meaningless if one does not experience the marketplace, for only in the marketplace will all the other lessons make sense.

Finding the right balance between education and experience is worth exploring. Some art schools and colleges may give credit for professional work; others may actively encourage that real assignments be given as part of the coursework. However the end result is achieved, a student should learn both in and out of the academic environment. It is never too late to enter the classroom, and never too early to experience the real world.

Beyond Technique

In general, I think any visual artist would benefit from studying the history of art and design, and from making it a habit to visit both public and private galleries. This is far more interesting and rewarding than poring over illustration and design annuals. It is useful to understand what social and historical circumstances led to the development of visual languages, as well as their decline. Internationally, there is a rich illustration and design heritage that, if understood by more practitioners, could enrich their work and help put current modes into perspective.
—Frank Viva

Becoming a Business

Commencement marks the end of one of life's chapters and the start of another. For art school graduates it also begins an obstacle course that has statistically many more failures than successes. Getting an illustration career off the ground is difficult under the best of circumstances, but in the current business environment what determines who will or will not succeed is subject to the vicissitudes of a fickle marketplace. Even having a strong portfolio does not guarantee that one will get career-launching assignments. There are simply too many artists vying for attention at a time when viable outlets are dwindling. Much like the acting profession the competition for every role—large and small—is immense. Akin to the notorious actor's "cattle calls," where hundreds of aspirants turn out to audition for even the smallest parts, portfolio days at popular magazines (the designated periods when unsolicited portfolios are reviewed) elicit scores of "books." At the bigger publishers there are so many that, owing to the sheer volume, some of the better examples may be overlooked.

Not having one's work in visible outlets insures invisibility. Since this is a time when art directors and art buyers are reluctant to actually interview artists face to face, much of an illustrator's self-promotion relies on frequent publication in highly visible venues. Some art directors have a monkey-see, monkey-do attitude: if they see that an artist has been used elsewhere, they will follow suit. Therefore, it is common to find certain illustrators published in a variety of places within the same period. Matt Mahurin is a good example. When he was just beginning he was assigned a cover plus inside illustrations for *Time* magazine on the theme of personal violence. He created a series of startling images seen by millions of readers and hundreds of art buyers. This one job did more to bolster his career than a dozen pages in any of the leading promotional books. Likewise, after photo-illustrator Amy Guip (see interview page 96) received her first couple of high profile jobs, other art directors began assigning her so much work that she was ubiquitous. Without intending it, the publishing and music industries, for whom she does the majority of her work, became her virtual promotion agents. Mahurin and Guip are among the lucky ones. While the field can be warm, welcoming and generous to a few, it can also be cold, rejecting and stingy to many more.

Questioning the Viability of an Illustration Career

DO NOT, HOWEVER, READ THIS AS defeatist but rather as a realistic, cautionary note. Understanding the pitfalls of this field is a necessary, though not always stressed, entry requirement. Deciding to become an illustrator is not as simple as having good drawing and/or conceptual skills—which is a predicament similar to other creative fields where perspicacity, tenacity, and luck really do determine one's future. The fact is that the world does not *need* more illustrators the way it needs other skilled professionals. While illustrators have contributed to popular American history—Norman Rockwell helped mythologize the American experience through his covers for the *Saturday Evening Post*—in today's diverse multimedia environments illustrators are not the essential personnel. Late twentieth-century computer technology has given more creative power to designers. It has also made certain kinds of routine illustration chores obsolete, in the same way that late nineteenth-century photography replaced many redundant forms. At the same time the computer has opened up avenues for new genres of illustration that will be discussed later. Yet even with multimedia as a siphon for talent, the large surplus of would-be illustrators will never be totally absorbed. Many illustrators will need to find ways of applying their talents in other areas of the arts and media.

This gloomy report is nonetheless mitigated by the simple fact that ours is an image-oriented culture. While fewer traditional illustrators are needed now than, say, thirty or forty years ago when most advertising was rendered by artists, illustration remains essential to certain genres where art and imagination are prerequisites. In the days when illustration was more ubiquitous a large percentage of what was being illustrated was actually mundane, such as product rendering and still lifes currently ceded to the photographer, and otherwise predigested, illuminated vignettes that tested little of the artist's intellectual capacity. Today illustration is generally more conceptual and also rooted in fine art. Successful illustrators need not be the meticulous renderers of impersonal tableau—or pairs of hands slavishly serving the art director's every whim—but rather impressionists, expressionists, and auteurs of sorts who are selected because they have distinctive graphic personalities (or in the worst cases can mimic the distinctive personalities of others). For those who possess skill, technique *and* imagination, illustration can be a viable, indeed satisfying career.

This is not to suggest that contemporary illustration is exclusively concept-oriented, nor does it imply that fulfillment rests on an artist trading only in concepts. There is still considerable demand for technical artists who render pure information for, among other things, imperial charts, graphs, and maps, and other objective themes such as science, medicine and technology. As the information business has exploded, so too has the need for highly skilled artists to render that which the photograph cannot do justice to. There will always be a market in these and other areas for superb renderers, especially since so much contemporary conceptual illustration leans towards the untutored look—a fashion, which like all fashions, will come and go. Those who can render lifelike recreations for themes such as nature, geography, transportation and so on, that require verisimilitude more than interpretation, will probably find reasonable

amounts of work. Illustrators with these skills will also become more in demand as new media increasingly changes the way information-based publishing, such histories or encyclopedias are illustrated.

The children's book field, which for over a decade has been fertile ground for many young illustrators, requires imagination but does not stress the need for conceptual thinking. Artists skilled at narrative storytelling, particularly those who can conceive, write and illustrate their own tales, can potentially make a career in this specialized area. However, while many artists have the chance to do one book, the likelihood of doing a second, no less a third or fourth, are much slimmer. Children's books may welcome the newcomer but owing to the mutability of the critics and marketing the field offers fewer second chances. Moreover, to succeed in the business of children's book illustration an

WHO'S THE CLIENT ANYWAY?

IT MAY SOUND ABSURD but knowing one's client is not always so clearcut. Often the real client for a particular job may be an invisible presence, heard but never seen, away in the background but definitely calling the shots. So for those who have been trapped in the Kafkaesque world of artist/client relations, and those who have yet to be baffled but someday will be, the following is a list of possible clients an illustrator may meet or not meet, as the case may be:

• ART DIRECTORS: The art director may assign a job to an illustrator, but may also delegate to an associate, deputy or assistant art director. Sometimes these delegates may have total control over the art, other times they must get approval from the art director. Ergo, if the delegate likes the work and the art director does not, the illustrator must answer to the art director.

• EDITORS: Most art directors and their delegates will have to show the illustration to an editor. If this is the chief editor then the process is simply yes or no. In some publishing companies subordinate editors are also consulted. If the subordinate is pleased and the chief is not, that means trouble. If the chief likes it and the subordinate does not, well, you get the picture.

• DESIGN DIRECTORS: In some companies the design director is above the art director. In advertising agencies the creative director is also so positioned (for procedure, see art directors).

• ART BUYERS: Depending on the company an art buyer is neither an art director nor editor, but the designated procurer of art and illustration who handles finances and contracts. Art buyers are rare in editorial, but if they are used the work will have to pass through the art director and editor. In advertising they are the conduit between the artist and the creative team. In such cases the art buyer will show encouragement but the art director of the creative team will provide the direction. The creative director will review the work, but the agency's client will have the final say.

• GRAPHIC DESIGNERS: Unlike art directors who are employed by a company, graphic designers are more likely employed by a design studio, firm or office. Sometimes the designer is also the proprietor, other times on the staff of the firm. If a graphic designer assigns an illustration he or she is likely working on a project for an outside client. At a small design firm, the proprietor (or partner) might make the assignment. At a larger office, a senior or junior designer might do the deed. In some cases the delegated designer may have total autonomy, in others the illustration must first be passed by the proprietor. In all cases, the design firm's client will have the final say.

• OTHER: Although these are the most common clients, assigning illustration is not limited to the above. Small companies may not have art directors, designers or art buyers. In this case any one in the company may do the work. Sometimes you may never know who the client is.

artist must invariably do many books to stay afloat. Henrik Drescher (see interview on page 92), an illustrator with almost twenty children's books on the market and a considerable number of awards for his efforts, claims that volume is imperative because fees are comparatively low in relation to the amount of time it takes to create a book. While it may be ego-gratifying to have a book published, financial precariousness is the name of this game.

Other non-conceptual genres that are visible but not necessarily lucrative from a business standpoint include fashion and portraiture. For years fashion has been dominated by photography, but a limited

CHOOSING AN ASSISTANT

GOING INTO BUSINESS for yourself is one of the most appealing aspects of the illustrator's life; your time and your work is your own. Why, then, do many illustrators take on assistants or interns? Your taxes, your billing and your portfolio, for starters. There is a lot in the realm of business affairs that has to be taken care of before a quiet falls over the studio and you can begin a project. A few top illustrators share their experiences about sharing their work load.

Once you decide you need an assistant, where do you begin? Julian Allen's assistants always come from his classes at Parson's School of Design. Allen says "After a year of teaching, you get to know someone." Steven Guarnaccia also finds his assistants in his classroom at The School of Visual Arts but he has other suggestions: "I have put up notices on job boards at art and design schools, even as far away as Rhode Island School of Design, and have had interns from schools all over the country. Word of mouth is a good way to find help, too." Amy Guip has not had much luck with job boards and recommends getting the word out among friends.

Unlike Allen and Guarnaccia, Guip is not keen on students. "They're too mixed up. They have energy and enthusiasm but, being so young, are easily distracted and could change direction on you. I had a horrible experience with a student. After establishing a trust, he stole books and my Rolodex from me."

Once you've carefully screened candidates, you must determine fair compensation. Guarnaccia says "I pay whatever I can afford; an hourly wage based on scheduled work. The assumption is that it's a short-term arrangement. The assistant is ending his or her student days and beginning a career." Allen bases fees on what other people are paying and will offer increases as the assistant demonstrates more skill. Guip pays $10 to $12 an hour, but points out that the real value of an apprenticeship cannot be measured in money. "My assistants have an extremely flexible schedule and have an opportunity to see how a studio is run. They get to learn who is working where and can meet people in the business." Allen offers free use of his studio and will occasionally recommend a student for professional projects.

All three stress that, for the assistant, the exposure to the illustrator's business is the most valuable part of the job.

Once you've worked out the financial arrangements, how do you keep them busy? None of our illustrators surrenders any creative decisions to assistants. They do, however, everything else: handle correspondence, billing, picture files, research, prop hunting or making, hiring models, developing pictures, accounting, bookkeeping, portfolio maintenance. Guarnaccia notes that "once the studio is running efficiently, the work just keeps appearing." Allen never has a problem with down-time because "I insist that my assistants have their own work to turn to when my work for them slows down. I want my assistant to grow wings and fly away." Guip keeps an eye on studio work load by anticipating busy times and arranging the schedule around it.

Illustrating can be lonely work and an assistant can provide much-needed company. Guip says "Having an assistant gets you up in the morning. I'd probably nap more if I didn't have one. It's nice having someone around. It can be close, intense work. My current assistant has become a friend."

SECOND RIGHTS: Life After Publication

PHOTOGRAPHERS HAVE had this option for years. Now illustrators are enjoying the benefits of a growing second rights market for pre-existing and already published work.

The concept is simple. For a certain fee (sometimes more, other times less than the original usage) illustrations can be bought and used for other purposes not necessarily originally intended by the artist. Second rights presupposes that the illustrator retains all rights to the work in question. If not, whomever owns these rights is entitled to use the work as they see fit.

Reuse is approached in various ways. Most commonly a prospective user will contact the artist or artist's representative directly. Fees are then negotiated based on the particulars of the client's needs. Less common, but gradually gaining acceptance, are stock agencies that take illustrations on consignment and pay fees when used. In this case, as with photographic stock agencies, catalogs are published that allow potential customers to see images, or upon request of a certain theme, the agency will send transparencies. A third, even less common approach is the illustrator who makes his or her own work available on CD ROM. Since CD ROMs are getting less expensive to produce, this technology could mean that illustrators might eventually have total control of their reprint rights.

With second rights and reuse becoming more frequent, illustrators are advised to retain the rights to their work and keep a sharp eye on their originals. They may be worth something sooner rather than later.

amount of stylized fashion illustration continues to be used in ads for magazines and newspapers. Although fashion drawing is frequently used in the actual design of clothing, one should not be misled into thinking that fashion illustration is a viable career path. All fashion designers must know how to draw. Yet the majority of what might be called fashion illustration is to fashion what architectural drawing is to architecture— simply a means of expressing ideas, not in and of itself an opportune business. Portraiture also fell victim to artful photography but is not yet extinct. Although portraiture is used in some editorial contexts and for the occasional annual report, it also is not, and probably will not be, one of illustration's more lucrative growth areas.

These are only two genres that might confound the neophyte when starting a career. Other illustration sub-genres may appeal to the young artist but will not offer a fruitful career path, either, depending on the needs of the field and level of competition within the genre. What must be addressed by the artist beginning in business is the issue of how to focus a viable practice. The merits of whether to be a specialist or generalist should be seriously weighed and the decision based on what exactly the artist wants out of an illustration career—be it creative satisfaction, fame, fortune or all three. Although the young can afford to experiment with different career options before settling on one, these early decisions will nevertheless be important ones and should be made with great diligence.

Cash Flow

Since I've been actively in the business (about six years), fees have gone down considerably in the editorial field. As a matter of fact, only a handful of magazines pay the GAG guideline's fee rates, and many design firms are paying pittances for relatively big jobs. Examples: *Premiere* magazine pays $150 for a color spot, Williams-Sonoma pays $350 for a black and white poster! These are grim amounts of money, especially when the GAG book is telling me that I should be getting $350–500 and $2500 respectively.
—Adam McCauley

WORKING ON SPEC: For Free or Not For Free. Is That the Question?

"SPEC" IS SHORT FOR speculation. An illustrator who takes on a spec assignment is therefore working for free on the chance that if the illustration is used it will be paid for. This practice is not uncommon with low-budget projects where money is tight, but is also frequently practiced by high-end operations as a means to audition new illustrators. There is, however, considerable debate among illustrators and designers regarding the efficacy and ethics of asking for and doing free work. Most other professionals would balk at such a request. So why should an artist be asked to gamble?

Spec work cannot be demanded or legislated. It is an individual decision. The neophyte illustrator may decide to do so because it is the proverbial foot in the door and getting a published piece (regardless of payment) will lead to more pub-

lished pieces. Other factors to consider include desirability of the job and the amount of freedom allowed. The payoff for free work should at least be a rewarding experience, and yet sometimes it can be as difficult as a paying job.

Doing spec work poses complex ethical dilemmas. Asking for free work implies casting couch behavior—i.e., some kind of quid pro quo. But what about those artists who decide not to speculate? Is work to be doled out on the basis of who will or will not cooperate? Spec is a double edged sword. It may open doors, but devalues effort.

Since rules governing spec do not exist common sense must prevail. Judge work on spec requests on individual merits. In addition, the following questions should be considered:
• Is the job interesting?
• Is the art director or art buyer

someone worth cultivating?
• What is the extent of the job (i.e., how many iterations, corrections, or revisions are you willing to do)?
• Is payment contingent upon publication?

Before entering into work on spec ascertain whether others are being asked to work on the same job (is this an exclusive or open audition?). If others are involved decide whether the competition is worth the time and energy. If this is spec work for a speculative project (i.e., a proposal for an ad campaign, book, or magazine dummy) agree to conditions that will protect your "intellectual" and "creative" property. As long as you are working for free, maintain all rights to your work.

Finally, make sure that you do not make a career of doing work on spec, lest you devalue yourself and your profession.

Specialization or Generalization

IF AN ILLUSTRATOR IS INCLINED toward fashion illustration, portraiture, or any comparatively arcane specialty they are best advised to analyze just how good they are in relation to their competition and how much steady business they can hope to receive based on their talents. Specialization in a tightly controlled or limited field might not be the wisest business decision. Of course, at the outset of a career it is better to test many waters before jumping in. But if driven by one's compulsion to practice in a difficult specialty, try it out for a limited time before

committing entirely. The fact is specialization can be injurious to some and profitable for others.

There are no hard or fast rules, just heartfelt instincts. As an example, Mark Summers, a Toronto-based artist who specializes in scratchboard portraits, has done extremely well because his work is exemplary regardless of its specialty. His nineteenth-century engraving style combined with extraordinary technical expertise and compositional skill results in pictures that are graphically eyecatching and artistically pleasing. His work is in demand owing to its undeniably high quality *and* the widespread visibility he gets in outlets like *The New York Times*

Book Review (where he is one of two regular portraitists) and Barnes and Noble bookstore (which uses his work for both storewide promotions and national advertising campaigns). While having talent is imperative, without this remarkable visibility he nevertheless could languish in his specialty. Summers made sound business decisions based on the knowledge that he could make an excellent living within this

narrow practice. He is one of the lucky ones: Being overly specialized can more often limit one's professional options.

A specialty, however, can mean different things, such as doing only one kind of work, like Sumers' portraits, or working in one genre, such as editorial art, or even one sub-genre, such as *humorous* editorial art, or even a sub-sub-genre, such as black-and-white humorous editorial art. Specialization also can mean having but one style regardless of assignment. But even specialization can lead to diversity. For example, Steven Guarnaccia (see interview on page 84) found his niche in conceptual humor. Even his assignments to illustrate serious themes always involve humorous solutions. Hence, in the editorial field he is called upon to tackle those often difficult subjects like the economy, where humor is used either satirically or sardonically as a counterpoint to the subject, or simply to take the edge off what might be otherwise turgid and pedantic. To Guarnaccia's surprise this has not limited his work to editorial assignments, although he began his career by specializing in editorial. His keen ability to transform mundane subjects into witty visual ideas has proved useful in advertising, corporate communications and other areas that he hadn't expected would result in viable career options. He has also found that after a few years of sticking to one style,

OUT OF TOWN, OUT OF MIND?

IT'S HARD TO IMAGINE life before overnight courier services, fax machines and E-mail. But there was a time when most illustrators had to live or work within striking distance of a major metropolis, preferably New York City. Even with an artist's representative pounding the pavement an illustrator was at a disadvantage if ensconced in the Maine woods or snowcapped Rockies. Jobs had to be completed days ahead of deadline; the mails were never guaranteed; and lost artwork was a real threat. Nevertheless, it was also possible, given the right circumstances, that an illustrator did not actually have to live within the city proper as long as the work was efficiently delivered.

Today, however, an illustrator can live and work almost anywhere in the world. This not only enhances the quality of life, but more important, by not settling in a major metropolis the overall dollar value of fees and income is increased. All an illustrator needs is a fax (which requires compatible phone lines) and a courier account (in areas that are covered by daily deliveries). Some clients absorb the cost of couriers. In the out-of-the-way locales the only drawback to the courier system is the comparably early pickup times, a small price to pay for otherwise remarkable efficiency.

In addition to the benefits offered by the above mentioned services, illustration jobs simply no longer emanate only from the few media capitols. Creative advertising agencies, editorial and book publishers are sprinkled throughout the country. Once the relationship between art director and artist was endemic to a healthy working relationship. Today the two often never personally meet.

But one word of advice: Not everything can be accomplished through a fax. For the long-distance neophyte it is a good idea to plan an extended visit to the major media metropolis. Even with an agent, personally making those important initial contacts can be worth the expense of the trip.

he branched out by doing variants on that style, such as adding watercolor, collage and three-dimensional elements.

Specialization based on one's strength(s) is quite common and sensible. The average editorial illustrator may not be capable of doing technical illustration, likewise a children's book artist might not be a good editorial illustrator. In fact, even if an artist were adept at all these genres, one's muse might militate against doing them all. George Williams, a highly skilled though fairly anonymous engraver and illustrator of banknotes and stamps for a leading banknote company, became a specialist in that area because his skill and financial needs demanded it. After five years of exclusivity, however, his restless muse urged him to move on and he decided to specialize in caricature, which he has done now for a number of years. While he relies only on a portion of his skill, this new art form freed him from the tedious exactitude of his old job. In this case his new specialization is not based on his obvious strength but the desire to work within a genre that offers more personal satisfaction. He has reconciled that caricature has limited applications and practices accordingly.

What can be surmised is that specialization works for some and not for others, and some specialties are less likely to provide steady work than others. But starting with a specialization, rather than being all over the spectrum, is not necessarily a bad idea if one can be mobile, flexible and prepared to alter course if the winds of the marketplace should suddenly shift.

Even among specialists there is a fair amount of "cross-over." Some notable examples include Henrik Drescher, who does both children's books and editorial (but no advertising); Brad Holland (see interview on page 74), who does advertising as long as it is approached in an editorial manner, meaning that he prefers to solve an advertising problem the way he would an editorial one—by conceiving the visual idea and rendering it the way he chooses, not as dictated by the client; Lane Smith, who is currently known for his children's books began, and continues to keep his hands in, editorial illustration. There are also those specialists who are quite happy to stick to one thing. Marshall Arisman (see interview on page 80) has done one children's book that was so totally consistent with his "adult" style that it could not be distinguished from his editorial work. Arisman has allowed himself to be pigeonholed as a predominantly editorial artist who almost always deals with the critical themes of social violence. Because this is totally in keeping with his fine art, Arisman has made no attempt to break through his specialty, which has worked well for him up to now.

Specialization can be profitable for those who know how to efficiently manage their talents and can further be a stage from which to experiment with other roles. It can also be a dead end if an artist is unable to comprehend the marketplace requirements regarding the limitations of the particular specialty. Most illustration programs encourage their undergraduate students to follow a general practice at the outset, and yet this does not necessarily ensure a plethora of work, either. The success of a general practice depends on exactly how *general* the artist decides to be.

In art school a general practitioner is one defined as adept at various approaches with a portfolio that exhibits numerous skills. A general course of study is designed to help the student identify his or

How Low Will I Go?

I start with a base hour rate calculating how long it will take me to do the job, then figure the way in which the art will be used and its applications. With the incorporation of computer art in my work, I need to know what will be done about output and running time. It helps to know the going rate per region. Also, buying a pricing guide book is important for further parameters for pricing within the industry. Also, I take into consideration whether or not future work could be obtained. I handle pricing with an intuitive eye as well as a business eye and am not afraid of asking peers for input.
—Phil Adams

STAYING POWER

MARSHALL ARISMAN. Seymour Chwast. Alan Cober. Arnold Roth. Edward Sorel. Each one has had an admirable career. Year after year their work continues to amaze, delight and, most importantly, get published. How do they do it?

• Marshall Arisman says, "I find that the more I know about my own process, the more I know about my own pleasures, the more I know about my own energies, the better I am at illustration."

• Seymour Chwast points out the importance of style. "It attracts art directors. You need to develop a style that people want. Some people have been able to keep working by developing such a strong original style that it outlasts trends. Drawing-based styles can lead to a long career because they aren't faddish."

• Alan E. Cober attributes his longevity "to the fact that I don't know what I'm doing. It's always brand new; I'm re-learning it each time."

• Arnold Roth says he's lasted so long because, with all the turnover in art directors, "there's always somebody new to fool."

• Edward Sorel contends, "I don't know how to do anything else. One of the nice things about this business is that there's a built-in apprenticeship; they pay you while you learn. At the beginning of your career, you can find low-paying jobs to do while you learn."

Long careers by definition mean fruitful relationships with a variety of art directors and art buyers.

• Roth says, "I have been friendly with art directors but I only moved to New York ten years ago so I wasn't going to parties or openings. People see my work and like it. I tend to let things fall into my lap. I really haven't hustled work."

• Marshall Arisman has found that "it's a pretty straightforward relationship. It's not their money, is it? It is their choice."

Over the course of a long career, styles will come and go. How do older illustrators stay fresh ?

• Cober notes that "something in someone else's style will attract you. But, real talent will cause growth. Also, I have what I call 'funnel vision.' I put a lot of things in my work to keep it fresh. Young art directors have said to me 'Judging from your work, you could be 25.' I've been drawing for 40 years. Is there a better compliment?"

• Roth notes that, for himself, fads don't matter. "I could have worked in 1810 or 1910 because I work in the established style of cartoonists, in a representational manner. But, trends seem to run in cycles so if you are working in the current popular style, you can expect it to fall out of favor. Trends are meant to change, it's of the moment. And, frankly, I feel my own ideas are stronger than some trends."

• Sorel links trend-following with personal vision. "You have to develop a personal vision. I didn't always have a style. I never thought I had one. It shocked me when people started to tell me I had a style. When you start out, you work in a manner that is comfortable for you until your own style appears. Of course, some people start out with their own style in place. I went to school with Seymour Chwast and he's drawing now the way he did at Cooper Union. And Milton Glaser was like a chameleon, he could do many things well.

There is no secret to longevity, but there are some tips to keep in mind. Sorel puts it this way: "I always figured I would get better. I am still interested in the work. Next year's pictures will be better than this year's. I haven't had any burnout because I am not bored."

her strength and bolster potential. Although with some illustration programs this implies the ability to work in a number of different, often unrelated styles, in the professional world general practice is not about becoming a stylistic chameleon. While being stylistically versatile might be considered generalization, in professional terms it is more like randomization, which although not altogether impractical is confusing to those art directors or art buyers interested in artists with personality or points of view. Hence, general practice does not mean that one has to possess multiple personalities, but rather should not be restricted to a single form or genre.

SURVIVING THE BLACK HOLE OF DROP-OFFS

SINCE IT IS VERY DIFFICULT to get a face-to-face appointment, the drop-off is the primary means by which the young illustrator can show an art director the unsolicited portfolio. The trick, of course, is to make your presentation as attention-grabbing as possible without going overboard. The following portfolio preparation hints might be useful:

• If the portfolio is unconventional, make sure it is durable. Artists will go to great lengths to be outrageous, sometimes to their detriment. Consider that the portfolio will be seen by many others. It will get bashed and bruised. Make certain your box, bag, or case is not damageable or easily destroyed.

• If it is a conventional portfolio, avoid the large ones in favor of medium-sized (14×17") "books" or cases. If your work is larger than this format, use transparencies.

• Avoid using originals. The likelihood of damage is great. What's more, 4×5" or 8×10" transparencies neatly mounted will prove a safer method. Of course, tear-sheets, xeroxes, or photocopies are fine. Try to keep from using snap shots or polaroids, which are simply too amateurish.

• Some illustrators include viewers or battery operated lightboxes in their portfolios. If you are using transparencies this is a nice touch.

• Don't get carried away with technology. Not every art director wants to see work on disk, and few have CD-ROM or Photo CD players yet.

• Include a good leave-behind. Keep the variety to no more than three different cards (or a well designed booklet might be useful). Often it is nice to address an envelope of leave-behinds to the art director, rather than including a notice that says, "Take One."

• Call for pick-up instructions. Do not let your portfolio stay longer than necessary.

• It's a good idea to have at least one back-up portfolio.

• See section on portfolios (page 120) and do your very best.

Seymour Chwast is the most innovative general practitioner working today. As co-founder in the 1950s of Push Pin Studios and currently director of the Pushpin Group, he integrates illustration, graphic design, product design and promotion into one generalized practice. Chwast calls himself an "illustrator who designs," and is fluent in both art and typography. As an illustrator he might have long ago become passé had he not diversified into a variety

No Boundaries

Being a freelance illustrator, despite some frustrations, is a great way to make a living. What other profession would enable someone who speaks an approximate English and who lives in a small town, outside Montreal, to make a very decent living with jobs coming from Canada, the United States and Europe? In what other professions do you keep getting better, higher paying and more interesting jobs all the time? Very few, I'm sure.
—Normand Cousineau

of publishing, advertising and animation fields, as well as expanded his visual vocabulary through different techniques. While these techniques—painting, drawing, wooducts and monoprints rendered in pastel, pen and ink, gouache, oil, colored pencil, color film and even tin—offer distinct effects, Chwast's approach is not so much a shift in styles as in method. His personality stays intact throughout the shifts in media.

In this way Chwast balances both personal needs and business requirements and maintains a distinctive "signature" while applying himself to as many market venues as possible without causing any confusion. Moreover—and this is the most brilliant accomplishment—all aspects of Chwast's work are harmonious, yet dis-

MEETING AN ART DIRECTOR

FACE TO FACE PROFESSIONAL encounters with art directors are rarer than hen's teeth. Most art directors are too busy with their daily routine to address the plethora of appointment calls. It's a sad fact of professional life. On the off-chance that seas part long enough to get a personal interview the following rules of etiquette should apply:

BEFORE CALLING:
• Know the art director's name and how to pronounce it.
• Know the art director's work. There is nothing worse than a blind phone call by an empty-headed caller.
• Make certain your work is appropriate to the art director's needs.

ON CALLING:
• Fast and simple: Do not be verbose. "I'd like to make an appointment to show you my portfolio," will suffice. If you are recommended by someone else mention that, too. Do not try to describe your work or where you've been published.
• Take the appointment date being offered. If there is an absolutely unavoidable conflict, say so, but otherwise remember that

the chance may not come again.
• Forget familiarity. If you are lucky enough to get the art director directly, avoid the "good-ole-boy" routine. It's not professional.

ON MEETING:
• Do not be late.
• Be as polite as you would like to be treated.
• Do not be surprised if your meeting lasts only long enough for the art director to page through the portfolio.
• Do not make conversation. Let your work do the talking. Offer a brief contextual comment only if necessary.
• Do ask pertinent questions if you think they're necessary. If the art director does not respond ask either "Is my work appropriate for you?" or "What do you think of it?"

• If the art director offers critical comments and/or advice, listen intently. Do not argue, but if unclear do ask for a clarification.
• If the art director does not appear to be interested do not ask for recommendations to others. If an art director does not care for your work the last thing he or she will want to do is refer you to a colleague.
• If the art director shows encouragement, ask if there is anyone else you should see.
• Offer the art director a leave-behind.

ON THE PORTFOLIO:
• Be professional. Bring either a handmade or conventional portfolio. Do not shove your work into an envelope or present on loose sheets.
• Time is short and valuable. Make your presentation as accessible as possible.
• Limit your samples to between 10 and 20. Do not bring an excessive number of tear sheets or originals. Do edit them so that they reveal the kind of work you want to get.

tinctive. Advertising cannot be mistaken for editorial, and editorial cannot be mistaken for children's book illustration. While each piece of work possesses spiritual, indeed physical, consistencies, the various forms have their own integrity. From a business standpoint Chwast's ability to shift from one role to another gives him considerably broader income potential than the specialist locked into a specific genre.

Deciding to be a generalist, therefore, means being at once solid and fluid in a field that shifts almost as often as the

tides. Yet avoiding the anonymity that could come with generalization is a challenge, which is why maintaining a personal mark—a distinctive characteristic unique to your work—is the key to staying in demand. Illustration is no longer a field for generic artists. While art directors and art buyers, particularly in advertising, may require "a pair of hands" to render predetermined ideas, more often than not the preference is for distinct personalities who, if not authors of ideas, at least invest the given ones with a heart and mind. To be a generalist, therefore, is not to con-

When did your stream of steady jobs begin?

I was living in Toronto and had only been in the business a year or two when I was hired to do a slew of illustrations for a start-up, the *Report On Business Magazine*. It featured a couple of sections of bite-size epigrams and statistical data—perfect fodder for humorous, quick little drawings. And to my amazement, the art director asked if I would be interested in doing the work every issue. I was delighted with the sudden opportunity for steady work, but I recognized the impending pigeonhole and, of course, I am to this day still inundated with calls for teensy, funny spots.

You had other aspirations?

Yes, almost all of which were fulfilled when I was offered "Citylife," a monthly back page for *Toronto Life Magazine*. It was a dream job, a page to do whatever I wanted. I got to carve up a number of reprehensible public figures and began developing a printed personality. My mistake was trying to do the job for too long. After two years, I moved to New York, but attempted to continue from my new home. I had Toronto newspapers delivered daily, and I tried to imagine I was still living there, reacting to what was going on. It was futile, so I quit.

How does one know when to terminate a steady assignment?

In every ongoing job there are going to be slumps. Then all of a sudden, you find you're enjoying yourself again. When you realize that the inspiration isn't coming back, it's time to go. It can be a hard thing to admit. One tends to become attached to a regular gig, to become territorial. Amazingly, upon leaving "Citylife," I was offered two new projects: *Entertainment Weekly* assigned me their "Hot Sheet" page (the requisite miniscule, madcap spot illustrations), while *The New York Observer*, a weekly newspaper, commissioned black and white portraits to pepper their dignified-looking front page.

Why do you think you continue to attract regular projects?

Speed is the main reason. So much of the material is topical and assigned at the last minute, you have to turn it around quickly. A sense of humor is also required, since so many of my illustrations are basically "punchlines," reactions to (rather than depictions of)

the text. The drawings should be loose, like they were scribbled in the margin while reading the piece.

What are the drawbacks of regular jobs?

Well, every Monday I've got eight drawings to do, like it or not. It sort of flies in the face of the freelance existence, which ideally can provide variety and change of pace. Scrounging for photo reference on a tight deadline can also be a major headache. And, of course, the person I'm dealing with makes a huge difference. An art director who's enthusiastic and organized can really help and inspire.

Besides the financial security, what are the advantages?

On a practical level, regular gigs really help develop the problem-solving muscles. *EW* gives me a few hours to come up with ideas—my "punchlines"—under not inconsiderable stress. "That which doesn't kill me makes me strong." Though it does make me wonder how Norman Rockwell turned out those *Post* covers week after week, year after year. It seems a superhuman feat.

What would your ideal regular job be?

Well, in the last year, *The New Yorker* has offered me as close to the ideal as I can imagine. A chance to contribute covers and cartoons of my own conception. Unlike the other gigs however, the onus is on me here; there is no deadline until I submit an idea and it's accepted—and that presents a whole new set of discipline problems. Hopefully, the earlier gigs have prepared me somehow.

sign away one's integrity, but to become more in demand for having that integrity.

For those who are wondering when the decision should be made, it's actually never too late to decide whether to become a specialist or generalist. Many illustrators change their methods when they perceive adverse shifts in the marketplace. Necessity dictates whether the generalist becomes a specialist or vice versa. Forty years ago illustrators dominated advertising until photography usurped their traditional role. Like dinosaurs many of these distinguished renderers became extinct. Some retired from the field while others changed direction. Tom Allen, who from the late 1950s to 1970s was one of America's leading impressionistic illustrators, and in the 1950s was a pioneer of an editorial style that supplanted the sentimental romanticism of the late 1940s and early 1950s, was forced to make a shift in his otherwise successful career. When advertising became less viable and the editorial outlets for Allen's impressionistic visual tableau began to dwindle, the artist refocused his efforts on children's books. Rather than strain to make conceptual art in the manner that the market was demanding, he found a specialty where his particular skills were best suited and where he could once again enjoy creative challenges. Allen successfully weathered his particular storms by adapting to what might be called the "nature of the business."

The Nature of the Business

L IKE ANY OTHER BUSINESS, THE business of illustration has a natural order resulting from the sometimes rocky marriage of convention and common sense. Business convention can be summarized by the maxim *keep a professional demeanor*. Common sense requires following one's intuition while at the same time keeping true to the above maxim. If this sounds a little vague it is

because there are no institutionally established rules, standards, or guidelines for running a successful illustration business. There are only suggestions based on an analysis of various experiences.

This is not to say that the illustration business does not operate on certain fundamental concepts. The first and most obvious concept is the deadline. Work is commissioned to be completed at a specific time. Unlike the *artiste*—the so-called bohemian whose life is so dedicated to the muse that time has no meaning—the illustrator is expected to deliver an assignment at an appointed time. No matter how brilliant an artist may be, lateness is intolerable and unprofessional. The chronically late can usually expect that their jobs will evaporate over time. While this may seem a rather simplistic reminder, the fact is that the conventions governing the business of illustration are simple.

Continuity is another key issue. When an art director or art buyer assigns an illustration they expect a certain degree of continuity between what they've seen in the portfolio or promotion piece and what the finished job will be. Therefore, changing one's fundamental approach, or style, in the midst of a job without giving any previous indication is bound to cause consternation. The nature of the business is such that radical changes are acceptable and at times even welcomed, but not without some warning. The comparison between illustrators, and say, auto repairmen offers an apt analogy: One would be miffed after taking one's car in for a tuneup, expecting professional consideration and coming out with a souped-up hotrod. The illustrator who is asked for one thing and delivers another is not acting professionally. Illustrators are hired for their intelligence, talent and style. With many

Cardinal O'Connor

(Opposite page) "Hot Sheet", Publication: *Entertainment Weekly*, Illustrator: Barry Blitt, Art Director: Michael Grossman; (Above): Title: *Cardinal O'Connor*, Publication: *The New York Observer*, Illustrator: Barry Blitt; Title: *Resolute Smokers*, Publication: *The New Yorker*, Illustrator: Barry Blitt, Art Director: Françoise Mouly.

THE NIGHTMARE CLIENT

IN A PERFECT WORLD, THE words "nightmare" and "client" would never be in the same sentence. Clients can be wonderful people who provide challenging work, human contact and pay. The trouble occurs when they try to get too much for their money or don't know what they want. The following are illustrators who have agreed to relive their difficult projects and offer a few tips on avoiding bad working conditions.

• **ROSS MACDONALD:** Hell is the controlling art director because you sense you are working with a frustrated illustrator. If an advertising job comes with a sketch from an art director, I reject the job immediately.

• **GENE GREIF:** Whenever the person who gives you the assignment says things like "dream job" or "total creative freedom" or "the job you've been waiting for," I immediately think this is going to be the worst thing that ever happened to me. The great jobs always start off very ordinarily, with no wild promises. Suddenly, you realize that it's going very well. But I have made the mistake of thinking that the person who gives me the job is the decision-maker, when it turns out that there are a host of other people involved. Usually the person you talk to is a middle man and can't help you or protect you at all.

• **MICHAEL KLEIN:** Bad jobs often start out all happy and pleasant. They tell you to "have fun with it" and "do what you want." Then they hire you and try to prevent you from accomplishing the thing you were hired to do. They just drain all your energy and you end up with no affection for the work. You send in a sketch that you know is good and appropriate and they kill it. You feel like they dialed the wrong number and weren't looking for you in the first place.

• **KINUKO CRAFT:** Thanks to my rep, Fran Seigel, I am spared a lot of this agony. She is very unambiguous about what is expected. But, recently I spent a lot of time and energy on a job. It started out being a cartoon style, then they changed and wanted a more realistic style. Something very simple had become very complicated. And a month had gone by that I spent solely on this project. Then we find out that there was a problem with money and I had only received a fraction of my fee.

• **BLAIR DRAWSON:** Jobs that look easy and sweet-paying should be fun but they often turn out difficult. I had a job once doing a brochure. The contact was very encouraging. She described the job and the ideas started flowing, which is usually a good sign. The trouble was there were a lot of middle men and the client had a tight, close rein. The work went back and forth forever. I was just fed up and wanted it to go away. Finally, it did. Then, six months later, they called back! The nightmare resumed. At this point, the contact had turned sour. The client tinkered with it so much. The weak ideas get promoted and the strong ideas are ignored because they are looking for the lowest common denominator.

• **ROSS MACDONALD:** I once did a job for an American magazine. They called me in a huge panic and asked me to send the art in a rush to Germany for publication there. I did what they asked, carefully preparing the package. A year and a half later, the art comes back to me ruined. It had just been stuffed in an envelope. It was all wrinkled up and there was this weird goo on it that smelled awful. It was either food or a hair product. I had heard from reliable sources that it had been published in Germany. So I called the magazine to ask about payment. They told tell me it never ran. I never got paid. .

jobs there is a wide tolerance within the berth of style. If a particular job demands a change of style, the professional thing to do is discuss it first.

Compromise is also endemic to illustration. Even if the illustrator is an exemplar of professionalism, delivers the job on time and adheres to a style, a particular work might be judged unacceptable for any number of reasons that rest with the illustrator, including misinterpretation of the problem, inappropriate imagery, or a clichéd solution. On the other hand, a client can reject a job owing to their own misreading, misunderstanding, or lack of vision. Nevertheless, the illustrator is bound by his or her professional conduct to reevaluate the assignment and make

The Curse of Style

One of the things I hate about illustration is that you "have" to have a style. That goes with what I said before. "They" won't take chances. If it was only for me, I would change styles on every job. The possibilities are so endless. Personally, I've changed my style every four or five years and hope to be able to continue to do so.
—Normand Cousineau

corrections or revisions. Refusing to do so is not the cardinal sin, but failing to explain why is. If the illustrator is not just a pair of hands then the art director should not expect him or her to acquiesce to every request. Nevertheless, if a conflict does arise professionalism demands degrees of compromise.

The business of illustration is based on trust. Even when a written contract exists between illustrator and client (which, incidentally, is rare) that delineates how many sketches, comps, or corrections/revisions are required, the cornerstone of the relationship is still trust: On the part of the illustrator it is to do the best job possible, which means understanding and at the same time pushing the limitations of the job. On the part of the client it is to refrain from the kind of interference that will squelch creativity and result in a mundane end product.

Illustration as Product

WITH ALL THE TALK OF ILLUS-tration as art, let's not loose sight of the fact that illustration is *also* product and should work as efficiently as any other product on the market. An uncomfortable chair, no matter how beautiful the design, is faulty merchandise. An inefficient automobile, no matter how enticing the styling, is a lemon. An inappropriate concept or rendering, no matter how "experimental," is a bad illustration. The Russian avant gardists of the early 1920s called themselves *Productivists* because they understood that they best served the Bolshevik revolution as applied artists, applying their artistic expertise to everyday products. Illustration may not be a pot, pan, or utensil, but in most cases it is seen in media environments that are practical, not ethereal. While many young and old illustrators might find the idea of their art as product anathema to why they became artists (albeit commercial artists) in the first place, it would be unrealistic to ignore the essential role that illustration plays in the worlds of publishing and advertising: to enhance, illuminate and otherwise draw attention to either a message or information. A client may profess to want an illustration for all the artistically-correct reasons, but never at the expense of the practical ones. Illustration is not an end in itself or art for art's sake, but must serve a function like any commercial good.

For all the creative license afforded to illustration, it must never be confused with fine art. Fine art implies experimentation without constraint. While the best illustration might also be great art, it achieves this status almost in spite of itself. Indeed it must first pass through a gauntlet of quality control tests that insure viability. It is the business of the illustrator to administer these tests

Managing Time

It is important to plan your time and schedule very carefully because once you accept an assignment, agree on the price and on the terms, the art buyer, agency and client are relying on you. Backing out in such a situation is the most unprofessional thing you can do, and will quickly win you a bad reputation. If you do not like the client, the job or the budget, or if a much better opportunity materializes after you have committed, it will be up to you to assess your short-term and long-term gains and losses, as well as your ethics, before deciding to dump one client for the benefit of another.
—Raphael Montoliu

DIGITAL ART: Illustration Today and Tomorrow

THE COMPUTER challenges the stereotype of the artist bent over a drawing table with brush or pen in hand. It also forces a reevaluation of what is illustration. Speed, accuracy and endless creative options are just a few of the advantages in using a computer to illustrate. The ability to make corrections or changes to a drawing without having to start over again can be a time-saver for the artist, but, on the other hand, it also puts the illustrator in the position of having to make unnecessary changes at the whim of an art director or client. Or worse, there is the danger of having a final piece of electronic art "tinkered with" by the art director after it is completed. This raises the question of what is original art.

Is the original the "copy" of the digital image that was sent to the client, as was the artwork in the traditional past, or is the original the master that remains with the artist? Without an actual, tangible object called "the artwork," what defines an original? No longer a piece that can be framed and hung on the wall, the value that an original piece acquires after it has appeared on the printed page has been lost. Who wants to own a floppy disk or a computer printout?

Frank Viva, an illustrator who has recently made the transition to producing all his illustrations on the computer, feels that the final printed piece is "the original." "For me, this is not fine art. When one of my illustrations is printed, it should look the way I intended it to be printed," he says. "The final piece, printed successfully, is what concerns me."

An illustrator turning to the computer has basically two options. The first is to take their existing style and recreate it. The second is to start anew by creating an approach that is a departure from their existing style. By learning new techniques and pro-

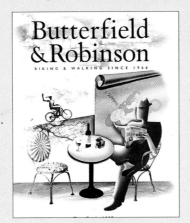

Butterfield & Robinson Catalog,
Illustrator and Designer: Viva Dolan.

cedures on the computer, the artist is faced with a whole new process and a different way of seeing both of which can have a liberating effect.

For Viva, the process of switching over to the computer was relatively seamless and while his style hasn't changed, he notes his art is easier and cheaper to work with, since art directors can place the image directly into their files. Before using the computer, he used to draw in black pencil and then airbrush over it. Now he draws it, scans it in and then airbrushes it in Photoshop. When

he first started out using the computer, Viva didn't want to learn everything about the programs. "I just learned enough to do what I do. It could be dangerous to focus too much on the technology," he says. "If I have an idea, I find out what it takes and I learn how to do it. I'd rather the illustration grows from an idea than from what the computer can do."

Viva says that art directors are more likely to make changes if they receive electronic files instead of a painting. "They seem to have more respect for a physical piece of artwork. I think it has cultural roots. Computer-generated art seems to be a couple of steps removed from reality for art directors." He also finds that some art directors have problems with storage and size of memory on their systems. Many are still working with low-level Macs, especially at magazines, and can't handle large files.

Barbara Nessim, who has been making electronic art created on computer since 1980, says, "I'm following my own path as far as my art is concerned, and I'm using the computer to realize things that I've had in my mind or on my wish list. For many, many years, there was no technology to do this." One of the projects she was able to realize is a small booklet, created from a database of over 200 of her drawings. This booklet originated with a work called Random Access Memories (RAM), an interactive fine arts exhibition in which viewers take a seat at the computer and construct a miniature art book. Each

one is completely unique and individually numbered. The chances of getting the same book twice are 48 million to 1. Not only did Nessim create the art, she also wrote the program for it using Hypercard as the base program. Nessim uses the piece as her business card and self-promotion piece, leaving it with art directors and other clients.

Unlike other illustrators who do their art solely on the computer, Nessim uses it only for specific tasks. In fact, her illustrations are still done by hand. "I can't use the computer when I have tight deadlines. It takes too long. I might on a rare occasion, but it's not something that I do first," she says. "When I think of the computer, I think of exploring and that takes more time, with more options to think about than just brush and paint." She still colors all her line drawings by hand, finding the quality of color printers not acceptable. "The Iris print is just getting to the point where I can use it, but the cost is too high," she points out. "Even storage is a problem. My work takes up a lot of memory, using up a whole Syquest sometimes." Nessim's advice to other artists is not to be afraid of the computer, "It shouldn't rule you. You should feel comfortable with it as a tool." She also adds that people should use it in a way that compliments their art. "It still doesn't replace handwork. It's very different."

With electronic illustration, the art director no longer has to deal with the color separation process, cutting costs and saving time. In contrast to saving costs at the client end, for the artist it means a huge investment in setting up a computer system, and maintaining it can have a dramatic affect on their business. It brings the illustrator up to par with the enormous overhead that photographers have always had to deal with. Also, learning the required

(Top) *French Lives*, (Bottom) *Japanese Lives*: Publisher: Nouvelles Images. (Center) *Random Access Memories Interactive Computer Art Mini Sketchbook.* Illustrator: Barbara Nessim.

skills and keeping up to date on software programs and hardware can cancel out the time-saving benefits of going electronic.

With the high costs of equipment, programs and other electronic services, conventional pricing structures cannot be applied to electronic art. Artists must now bill for expenses such as scanning and image manipulation; color printouts and Iris proofs; trapping and the creation of color separations; transparencies, slides and film output; software purchases, disks and cartridges; and equipment rentals. These expenses need to be discussed with the art director or client before beginning the job. Making the adjustments in pricing computer-generated art may be a slow and frustrating process, especially since illustration rates have not increased much in the last twenty-five years.

The use of reference materials in electronic art as collage has become a popular trend with designers and illustrators, but there is very little knowledge of legality regarding the copyright of images. Copyright laws for art created electronically are exactly the same as any other visual artwork. In order to avoid copyright infringement, one should obtain permission in advance for the intended use, including distribution and display of the work.

Before investing in the process, an illustrator should consider the high costs of setting up and the time it will take to master the technology. How can this new tool improve your art? Are you prepared to deal with the frustrations of learning the software programs? Can you handle unexpected technical glitches? Do you have the proper support?

New technologies in the area of electronic imaging will continue to influence and affect how illustrators work, but there remains one important factor that has not differed from the traditional past: talent and skill are still required.

before the client receives the job. Therefore the illustrator who knows how to balance his or her own creative desires with the requirements of a job possesses both invaluable artistic *and* business skill. Knowing how far to push the product to the limits of acceptability while not falling into the trap of convention is a must if one is to be a successful illustrator.

Furthermore, an illustration does not only serve a decorative or conceptual function, it must also be reproducible. Art talk is just gibberish if the work does not translate from original to print, so the product must pass muster on a technical level, as well. Veteran illustrators know exactly how to gear their materials for specific media, not only because of business, but because the integrity of their work demands it. One of the best services a school can provide is to teach students these skills before they enter the professional world. Nevertheless, the bulk of these skills will be learned through on-the-job experience.

Product Value = Self Worth

IF AN ILLUSTRATOR ACCEPTS THAT illustration is product then the same standards applied to the manufacturers of commercial goods should also apply. This is not to say that illustrators need a union, but unanimity in terms of ultimate goals is not too much to ask for. Often a client wants (indeed, needs) the product but views its producer as a sometimes eccentric *artiste*. If illustration is the business it is purported to be then its principals are business people who should be afforded the same respect as other producers and marketers. Although trade organizations, most notably the Graphic Artists Guild, do an excellent job at attempting to set standards and provide guidelines geared for the illustrator and client, in the final analysis it is the illustrator who must be the exemplar of professionalism.

The most important step in establishing this professional demeanor is to invest the work with value, which gives the illustrator a sense of self worth. While it is true that value is often determined by a client's fixed budget (i.e., *Time* magazine pays a fixed rate to its editorial illustrators based on usage), the illustrator must make his or her economic concerns apparent from the outset. Even a neophyte can ask the simple question, "What is the budget for this?" which indicates to the client that one is not doing this for love. Despite the personal passion and pleasure invested in a job, money is an important factor. No matter how young or inexperienced, an illustrator should not give it away. Although respect for one's talent cannot be bought or sold, professional respect is a matter of establishing signposts. Even in a situation where a low fee is acceptable, the client should be made aware that the illustrator knows that the fee is low. Ignoring finances, even in the excitement of getting a great job, is signaling a disregard for value and worth that will possibly have adverse effects later. Incidentally, if a fee is perceived as too low, there are benefits to saying no thanks. Self worth is knowing when to say you're sorry.

Timely billing is an effective way of telling the client that one is business minded. Toward this end The Graphic Artists Guild makes available models for invoices and purchase agreements which, when used with the GAG logo, has the added impact of being business-minded with a membership in a trade/advocacy organization.

In addition to understanding basic fees, asking for kill or sketch fees is imperative in establishing product value. There are various reasons that a job might

be killed or canceled, but if an illustrator has been assigned the job and labor has been expended in good faith, then that labor should be compensated for even if the job is not used. It is standard practice for a client to pay a fee for a sketch if the job does not go to finish. Either full or partial payment is paid for a finished job if it is killed. In both cases there are no fixed rates, but it averages around one quarter for a sketch fee and one half to all of the agreed to finished fee for a kill. Not all clients offer these alternative fees, but that should not stop the illustrator from asking for or demanding them. Work done should be paid for.

As long as the client has assigned the work kill and sketch Fees should be expected if an illustrator has done the labor even if the client finds it unacceptable. Usually, the client will have to reject a number of the sketches before terminating the job. By that time even if none succeed an illustrator will have invested recompensible time. The only time such fees are in doubt is when the artist violates the terms of assignment and simply does not fulfill his or her obligation.

One final, but no less important, note on product value has to do with "work for hire." This seemingly harmless little phrase usually affixed to the bottom of a purchase order or the back of a check indicates that all rights to a completed work belong to the client. An illustrator should avoid doing work for hire jobs, particularly when the fee is low. Work for hire allows the client to use the illustration for whatever purpose and for as many times as needed. High-paying jobs, often for advertising clients, are routinely work for hire (and the higher the initial payment the more sense it makes), but certain lower-paying clients might try to sneak work for hire stipulations through. Be careful, and be certain to make intelligent decisions.

Good Business Makes Good Sense/ Good Sense Makes Good Business

IT CANNOT BE REPEATED TOO OFTEN that illustration is a precarious career to enter if one is totally lacking in business savvy. The overwhelming majority of illustrators are freelancers, and so financial stability is always in question. If one is looking for a sturdy financial base be advised that the majority of illustrators—even some of the most successful—experience fluctuation in their billings from year to year. One's livelihood is at the mercy of both regular and irregular clients, for whom loyalty is defined by the saying "What have you done for me lately." And yet while the odds are against the majority of illustrator wannabes, the statistics also prove that a sizeable number of illustrators have flourished as freelancers. In chapter four of this book, "On Being An Illustrator," eleven veterans—freelancers all—talk about how each of their balancing acts work for them.

Genres, Media and Tools

Weekend painters always wish that Sundays could last forever. They fantasize about a life in front of their easel, brushes and palette in hand, alone with their muse and free from the drudgery of the daily grind. Their tools become charged symbols of a freedom that for many comes only with retirement. In this sense illustrators have a rich life. Although perhaps not totally free from the daily grind, they do enjoy the next best thing: A job in the art world. And yet romantic ideals notwithstanding, illustration is a fulltime *job* that requires hard work and dedication. Successful illustrators hone certain skills and develop expertise in enough of the available genres that make their illustrations commercially viable.

The number of significant illustration genres—those that provide regular work for a majority of practitioners—underscore the diversity of this seven-day-a-week profession. If one genre doesn't fulfill an illustrator's creative or financial need, another will. Artists who have mastered many kinds of generic work, such as editorial or advertising, are obviously better situated to succeed. But specialization can be lucrative, too. If, for example, advertising does not provide the emotional rewards, illustrating book jackets or children's books for a publisher may do the trick. Even within these genres there are different ways to approach one's art, among them, conceptually, decoratively, technically and narratively.

Decades ago illustrators were limited to a few primary tools: oil, egg tempera, watercolor, pen and ink, scratchboard and of course, air brush, the essential tool of commercial art. Styles were limited as well. Today, the field embraces the traditional as well as radical: collage, photomontage, wood, modeling clay, papier mâché, stencil, even street garbage or virtually anything that can be made into an image is appropriate. Let's also not forget the computer, the single most revolutionary tool at the artist's disposal. Computer art, though fortunately not as ubiquitous as originally predicted, is slowly earning a place next to other non-novelty tools.

Whatever genre or genres an illustrator chooses to practice, in whatever style and tools, it is important to do so with complete dedication. This should not, however, imply rigidity. An illustrator should be fluent with many approaches. The key to which should take precedence can be easily measured by the results. If watercolor is the most effective way to convey editorial ideas, or gouache is best for rendering the technical detail, or pen and ink is the foremost method of achieving personal expression, then these should be practiced. In illustration the specialist may decide that adhering to one is key to success, while the generalist may find pleasure in playing with a variety. But remember, an illustrator can be a virtuoso in more than one genre or with more than one tool—the trick is knowing them well enough to claim expertise. That comes with time, practice and intelligence.

THIRTY YEARS AGO virtually all editorial illustration was realistic, often sentimental or romantic. Today diversity reigns, and artists run the gamut from hyper-realism to total abstraction.

1 C.F. Payne's fanciful portrait of Who guitarist Pete Townsend is not your typical cartoon even though it is a subtle caricature. Rather it is rendered realistically with attention to great amounts of detail. This realistic vignette, using mixed media (acrylic, pencil), is a striking counterpoint to the hypothetical characterization of Townsend as a child. Illustrator: C.F. Payne; Client: *Rolling Stone*; Title: "Sorry Mom Can't Explain"; Art Director: Fred Woodward.

2 Julian Allen is a master at rendering the hypothetical as this portrait of Ross Perot suggests. Allen's realistic watercolor rendering is based on photographic reference, but places Perot in a fictional, though not improbable, composition. Illustrator: Julian Allen; Client: *Newsweek*; Title: "The Perot File"; Art Director: Peter Comitini.

3 Collage and cartoon are the tools David Goldin uses to create comic vignettes. A blend of pen and ink, watercolor and "found materials" result in a witty style that both rejects realism and celebrates the comics. Illustrator: David Goldin; Client: *The New York Times Magazine*; Title: "History of a Hoax"; Art Director: Janet Froelich.

4 James Steinberg takes a minimalist approach to this travel magazine cover which is rendered on two levels: On the bottom a representation of the traveler rendered impressionistically in gouache, and on top simple outlines of international symbols. The background color field is used to contrast the linear from

1

2

3

4

5

6

8

tonal rendering. Illustrator: James Steinberg; Client: *The New York Times*; Title: "The Sophisticated Traveler"; Art Director: Nikki Kalish.

5 In the 1920s German Dada artists Raul Hausmann and Hannah Hoch cut up newspapers, magazines and books and reconfigured them into totally new images. Stephen Kroninger continues that tradition with caricatures pieced together from "found" materials. Compared to more rendered portraits this caricature of David Letterman evokes a playfully comic sensibility. Illustrator: Stephen Kroninger; Client: *Entertainment Weekly*; Title: "Letterman"; Art Director: Mark Michaelson.

6 Surrealism is the displacement of the real for the unreal. In illustration it is used to compress various ideas into one image. Brian Cronin employs the conventions of surrealism— a barren landscape, large and small figures—to convey the sensation of being trapped. Illustrator: Brian Cronin; Client: *The Boston Globe*; Title: "What's the Matter with Men?"; Art Director: Lucy Bartholomay.

7 Paul Davis' dramatic portrait of Martin Luther King is painterly, though not sentimental. Based on photographs the work captures the essence of the man through detail and nuance rendered in acrylic. Illustrator: Paul Davis; Client: *Rolling Stone*; Title: "Martin Luther King Jr., Hero to a Generation"; Art Director: Fred Woodward.

8 Parody is key to Ross Macdonald's commentary on the all-American family. This image is both influenced by and satirizes a 1940s and early 1950s style of idealistic illustration. It is not merely a pastiche of the past but the foundation for a personal style. Illustrator: Ross Macdonald; Client: *GQ*; Title: "You Are What You Shoot"; Art Director: Robert Priest.

9 David Johnson renders detailed portraits in line with pen and ink. Paying meticulous attention to the lines and crags on the face, Johnson's pictures accentuate those characteristics that define the individual. Illustrator: David Johnson; Client: *The New York Times Book Review*; Title: "Walter Lippman"; Art Director: Steven Heller.

10 Kinuko Craft is a master of recreating the most complex painting methods of the past as appropriate illustrations for the present. This cover on Russian Nationalism weds Byzantine art to a contemporary idea for an iconic result. Illustrator: Kinuko Craft; Client: *The New York Times Magazine*; Title: "Yearning for an Iron Hand"; Art Director: Janet Froelich.

11 A simple black and white ink drawing rendered with brush can be extraordinarily expressive. Anthony Russo's "headers" for *The New Yorker* magazine's columns are economical vignettes that possess a graphic wallop. Illustrator: Anthony Russo; Client: *The New Yorker*; Title: "The Critics, Shouts and Murmurs, In The Mail." Art Directors: Wynn Dan, Caroline Mayo.

12 Collage has many variants and a very popular one is cut paper. In a comically expressive example, Michael Bartolos uses the medium with the fluidity of paint. Although the subject is adult, the style suggests juvenile primitivism—an effective way to handle otherwise mundane material. Illustrator: Michael Bartolos; Client: *Bloomberg Magazine*; Title: "Home Depot"; Art Director: Sarah Stearns.

13 The fluid pen and ink line remains the most com-

9

10

IN THE MAIL

11

12

13

TOMORROW'S NEWS TONIGHT—STEVE BRODNER

14

15

16

17

mon illustration approach, but Steven Brodner applies it to the most uncommon caricatures. This series is an ongoing panel he distributes to newspapers and magazines. Illustrator: Steven Brodner; Client: Various; Title: "After Manassas"; Art Director: Steven Brodner.

14 After pen and ink, scratchboard is the most frequently used medium. It provides the graphic quality of a pen and the precision of a wood engraving. Cathie Bleck gives a sense of drama and monumentality to this romantic and symbolic image. Illustrator: Cathie Bleck; Client: *Stanford Medicine Magazine*; Title: "High Risk Pregnancy"; Art Director: David Armario.

15 The computer has opened heretofore unknown possibilities for graphic imagery. This cover suggests possibilities for decorative computer-aided art. Illustrator: John Hersey; Client: *Aldus Magazine*; Title: "News For the Eyes"; Art Director: Kristin Easterbrook.

16 When the airbrush was introduced in the early 20th century it was for retouching use. Today it is a creative tool. In Jose Cruz's hands it is a means of making highly stylized sculptural drawings. Illustrator: Jose Cruz; Client: *Business Week*; Title: "America's Hottest Exporters"; Art Director: Francesca Messina.

17 Despite illustration's fluctuating fashions and trends, the classical approach is always a favorite. Mark Summers, a master of scratchboard, creates remarkably detailed, formal portraits, with a hint of caricatural quirkiness. Illustrator: Mark Summers; Client: *The New York Times Book Review*; Title: "Joseph Conrad"; Art Director: Steven Heller.

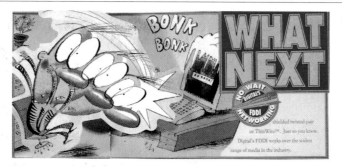

LIKE EDITORIAL, the genre of advertising has become more diverse in terms of media and method. And yet, while abstraction is often employed, realism (romantic or otherwise) remains the preferred approach.

1 Hal Mayforth's comicality is unusually appropriate for an ad that asks the question "What Next?" when the personal computer freezes. This comic book approach rendered in ink and watercolor absurdly goes where realistic art (or a photograph) could never go—to the edge of perception. Illustrator: Hal Mayforth; Client: Digital; Title: *What Next?*; Art Director: Joe Kravec.

2 Certain advertisers prefer abstract or witty illustrations to either attract attention or avoid too much emphasis on the product itself. Philippe Weisbecker's comic battle, rendered in ink and watercolor and derived from 19th-century French Epinal prints, engages the viewer on various levels. Illustrator: Philippe Weisbecker; Client: Chanel; Title: *The Blue*; Art Director: Alain Lachartre.

3 A classic appropriated and transformed is how best to describe this brilliant adaptation of daVinci's most famous lady. Mark Hess' rendering in oil twists and inflates the original into a work of hilarity. Illustration: Mark & Richard Hess; Client: Prince Spaghetti Sauce; Title: *Original & Chunky*. Art Director: Bob Barrie.

Original. Chunky.

5

4

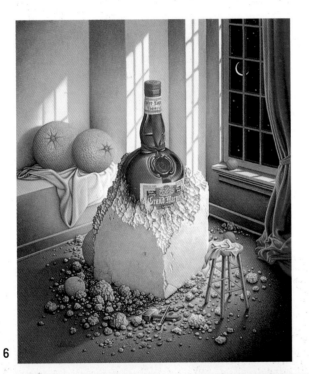

6

7

The waiting is over.

4 Before the ascendancy of the photograph, most fashion advertising used elegant drawings. As a counterpoint to today's conventional ads, Barry Blitt's newspaper fashion spot, rendered in pen and ink, is a low-key, but high-visibility promotion. Illustrator: Barry Blitt; Client: Barneys New York; Title: *Can You Say Evenegildo?*; Creative Director: Ronnie Cooke.

5 With scores of running and hiking shoes on the market, how a company distinguishes their brand is critical. In this case the shoe is the only thing that will save this unfortunate hiker from the perils of the forest. Rendered in ink and watercolor, Jack Unruh exploits the viciousness of the "hairballs" and exaggerates perspective to increase the drama. Illustrator: Jack Unruh; Client: Avia; Title: *Bear*, Art Director: Bob Pullam.

6 René Magritte has been the model for American illustration spanning over three decades. For this ad, one in a series illustrated by Braldt Bralds in gouache, the spirit of Magritte has been invoked as a means to artistically celebrate the product and its essential characteristics. Illustrator: Braldt Bralds; Client: Grand Marnier; Title: *A Grand Inspiration*; Art Director: Arnie Arlow.

7 Of late fashion advertising has broken many of its own conventions. When once it was necessary to show garments in a mythical light, today abstraction that evokes allure is enough. JeanPhilippe Delhomme's colorful gouache paintings of enigmatic characters in fashionable dress have become symbols of the store which they represent. Illustrator: Jean-Philippe Delhomme; Client: Barneys New York; Direct Mail Piece; Creative Director: Ronnie Cooke.

8 Combining a fore-shortened perspective with professional realism, Mark Ryden has created a vignette, painted in acrylic, that positions these sneakers as a playground athletic shoe. Illustrator: Mark Ryden; Client: Nike; Title: *Michael Jordan*; Art Director: Michael Morrow.

9 Using the pastiche of the 1930s Ross Macdonald recalls the grand era of train, ship and air travel. Painted in watercolor, this image includes many of the elements needed to tell a complex story. Illustrator: Ross Macdonald; Client: External Affairs Canada; Title: *Bon Voyage But...*; Art Director: Louis Fishauf.

10 Bus side advertising speeds by in an instant, so the message must be clear but eye-catching. Gary Baseman's colorful cartoon, painted in acrylic, is just that. Illustrator: Gary Baseman; Client: Utz Potato Chips; Title: *No Utz in Miami Beach*; Art Director: Ken Denison.

11 Advertising for Halloween candy abounds with clichés. Alex Murawski succeeds where many might fail because his stipple approach to illustration adds a new dimension to graphic presentation. Here his wild things act as a totem to appetite appeal. Illustrator: Alex Murawski; Client: Nestle; Title: Halloween Promotion; Art Director: Francesca D'Esterno.

12 Shakespeare's plays have been performed again and again, so how best to advertise yet another performance? Rafal Oblinski transformed the bard into a jogger—a fitting metamorphosis for this urban event. Illustrator: Rafal Olbinski; Client: New York Shakespeare Festival; Title: *Free Shakespeare in Central Park*; Art Director: Ann Murphy.

8

9

10

11

12

13

14

15

16

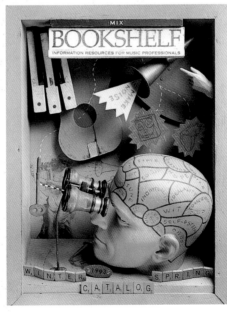

17

13 James McMullan, a master of watercolor, has revived the 19th-century tradition of the illustrated theater poster. Through his distinctive work for Lincoln Center in New York, McMullan has created an identity for a diverse array of cultural events. Illustrator: James McMullan; Client: Lincoln Center Theater; Title: *Carousel*; Art Director: Jim Russek.

14 James Kraus was commissioned to produce a number of graphic icons, created with Aldus Freehand, and used throughout the text of an advertisement to underscore various key points. Illustrator: James Kraus; Client: Duvall, Bruckner & Partners; Title: *CGI Brochure*; Art Director: Kevin Miller.

15 As mailorder grows in popularity, the graphics are improving, albeit through exemplary photography. Robert E. Hagel's drawings in pencil and watercolor appeal to the homespun sensibility of a potential buyer. Illustrator: Robert E. Hagel; Client: The J. Peterman Company; Title: *Owner's Manual No. 14*; Art Director: Robert E. Hagel.

16 Mark Frederikson has made the art of exaggeration into a science. His advertisements for a range of products are influenced by sci-fi shockers, but are as absurdly comic as *Mad* magazine. Illustrator: Mark Frederikson; Client: Levis, Mead Corp.; Title: *Horror Flickus Addictus, Bulldog & Caveman*; Art Director: Andrea Hyet, Marna Henley.

17 The diorama is used frequently to evoke a sense of past or present, and to provide another dimension of visual experience. A combination and collage of antique artifacts implies the search for music-related materials. Illustrator: Gary Tanhauser; Client: Moyer Bookshelf; Title: *Winter/ Spring Catalog*; Art Director: Michael Zipkin

Despite the cuts in library budgets, which account for a large proportion of sales, the children's book market remains fertile for illustrators who can spin their own yarns. A large number of children's book illustrators are writers too, making this field the most challenging of all the commercial arts.

1 As an editorial illustrator Richard McGuire uses minimum line for maximum effect by wedding graphics and concepts that are deceivingly simple. For his children's books his economical style, which evokes the early learning books of the 1940s and 50s, grabs the eye and peaks the sense of young and old. Illustrator: Richard McGuire; Client: Viking; Title: *Night Becomes Day*; Art Director: Richard McGuire.

2 Peter Sis began his career as an editorial illustrator but his meticulous pen, ink, and watercolor approach and fanciful, surreal narrative style are also well-suited to children. For this drawing done for *Three Golden Keys* his "adult" style is easily translated into something a child can appreciate. Illustrator: Peter Sis; Client: Doubleday; Title: *Three Golden Keys*; Art Director: MarySarah Quinn.

3 How to make computer-generated art uncomputer-like was J. Otto Siebold's challenge. And he succeeded by creating a character—the dog named Mr. Lunch—whose adventures take him through a comically surreal environment. That the imagery was done on computer seems merely incidental. Illustrator: J. Otto Siebold; Client: Viking; Title: *Mr. Lunch Takes A Plane Ride*; Art Director: J. Otto Siebold.

4 In addition to original stories, the children's book field is replete with adaptations of classics. David

1

2

3

4

5

6

"...It's amazing what one misses without one's glasses, hmmm?"

7

8

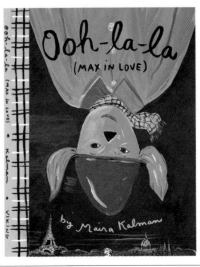

Ooh-la-la
(MAX IN LOVE)

by Maira Kalman

Johnson discovered an old fable, which he reinterpreted in both word and picture. His typically linear art done in ink and watercolor, which is already informed by Japanese art, was well suited to this story set in ancient Japan. Illustrator: David Johnson; Client: Rabbit Ears Productions; Title: *The Boy Who Drew Cats*; Art Director: Paul Elliot.

5 Artists are always in demand to illustrate writer's texts. Marc Rosenthal's distinctive touch is the backbone of this comic tale, and his humorous drawings in ink and watercolor bring the words to life. Illustrator: Marc Rosenthal; Client: Alfred A. Knopf; Title: *Peter and the Talking Shoes*; Art Director: Denise Cronin.

6 Lane Smith is a painter with a passion for collage. His mixed media illustrations are used with great effect in telling picture stories for children where he combines fantasy, comic nonsequitur, and conventional narrative into a carnival of imagery. Illustrator: Lane Smith; Client: Viking-Penguin; Title: *Glasses Who Needs 'Em?*; Art Director: Molly Leach.

7 Working hand in hand with an author, Lane Smith visually reinterprets a classic children's tale. His unique, postmodern characterizations of *The Three Little Pigs* that wink and nod to the past brings the story to life for a new generation. Illustrator: Lane Smith; Client: VikingPenguin; Title: *The True Story of The Three Little Pigs*; Art Director: B.G. Hennesy.

8 Maira Kalman's sophisticated primitivism brings her canine character to life. Client: Viking; Title: *Ooh-la-la (Max In Love)*; Illustrator: Maira Kalman; Art Director: Scott Stowell.

It is not impossible to make a decent living in the field of book jacket/cover illustration. Despite a shift towards typographic jackets, illustration continues to be popular for certain publishing genres where mystery, drama and comedy are virtues.

1 This elegantly simple ink and gouache painting suggests the opposition in the title of the book. Illustration: Karen Caldicott; Client: Vintage; Title: *Night and Day*; Art Director: Peter Dyer.

2 For this graphic translation of Cole Porter's classic lyrics, Ward Schumaker illustrates the song in a lighthearted, romantic way. His drawings, rendered in ink with patches of watercolor, rely on the nuance of line to tell the story. Illustrator: Ward Schumaker; Client: Chronicle Books; Title: *Let's Do It*; Art Director: Michael Carabetta.

3 Stephen Kroninger employs expressionistic collage to suggest society's slavishness to media, and by extension its need to thwart media censorship. Illustrator: Stephen Kroninger; Client: Thunder's Mouth Press; Title: *50 Ways to Fight Censorship*. Designer: Stephen Kroninger.

4 Focusing on an object is yet another way to invoke symbols. This woodcut by Lars Hokanson evokes time and place as well as the key element of this novel—the telephone. Illustrator: Lars Hokanson; Client: Macmillan; Title: *Hope Will Answer*; Art Director: Wendy Bass.

5 Paul Davis' portrait of Joe Papp, the empresario of American theatre, captures the essence of a man who was part showman, part visionary, part egotist. Illustrator: Paul Davis; Client: Little, Brown; Title: *Joe Papp: An American Life*; Art Directors: Steven Snider/Paul Davis.

1

2

3

4

5

6

7

8

9

10

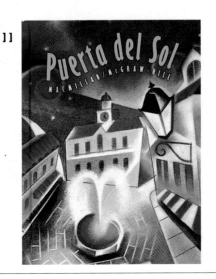

11

6 Ed Lindlof's cornucopia of Southern foods rendered with complete attention to detail is an example of how effective stylized realism can be. Illustrator: Ed Lindlof; Client: University of North Carolina Press; Title: *Bill Neal's Southern Cooking*; Art Director: Rich Hendel.

7 Caricature is often an enticement to a reader, and Barry Blitt's illustration in ink and watercolor comically introduces this witty book. Illustrator: Barry Blitt; Client: Vintage Paperbacks; Title: *Literary Trivia*; Art Director: Susan Mitchell.

8 A simple yet striking rendering of a soul in despair is the perfect graphic solution for a book about human torment. Brian Cairns' minimalist image, done in gouache, is both illustration and symbol. Illustration: Brian Cairns; Client: Vintage; Title: *An Evil Cradling*; Art Director: Peter Dyer.

9 This novel of suspense is craftily illustrated with a portrait of the protagonist reaching for a high fly as he is targeted by an assassin. The painting forces a double-take designed to capture the reader's interest. Illustrator: Steve Carver; Client: Penguin USA; Title: *The Plot To Kill Jackie Robinson*; Art Director: Neil Stuart.

10 A computer is used to get the ghostly effects found in this piece by Richard Tuschman. The graphic elements are composed to frame the title and suggest the scientific and artistic aspects of this story. Illustrator: Richard Tuschman; Client: Henry Holt & Co.; Title: *Various Antidotes*; Art Director: Raquel Varamillo.

11 By employing a Cubist perspective Jeanne Fisher's pastel rendering of this serene plaza underscores the title of the book. Illustration: Jeanne Fisher; Client: Macmillian/ McGraw Hill; Title: *Puerta del Sol*; Art Director: Sharon Gresh.

Technical

THE TECHNICAL illustrator must be a master renderer and a patient student of intricate material. This form of illustration can be stylized but not to the extent of obfuscating the pertinent visual data.

1 Using Photoshop, Geoffrey McCormack has collaged all manner of images representing the electronic media for a print advertisement. Illustrator: Geoffrey McCormack; Client: CCOR/ Comlux Inc.; Title: Digital Fiber Optic Transmission of Video; Art Director: Thomas Washburn.

2 Skip Baker draws this blueprintlike rendering of a mousetrap in colored pencil as a way of showing his expertise in the art of detail. Illustrator: Skip Baker; Client: None; Title: Muscipula Mousetrap; Art Director: Skip Baker.

3 Imagine how difficult it is to build a performance car, and then think how hard it is to render every last detail in ink, watercolor and airbrush. The attention to detail is awe-inspiring. Illustrator: Ron Fleming; Client: Bernstein & Andriulli; Title: *Pantera*; Art Director: Ron Fleming.

1

2

3

WHO WOULDN'T WANT to see their illustrations move? Animation has always been a magnet for artists and with advanced technologies, a variety of animation methods are available. This is a field that offers real potential.

1 Brian Ajhar created over 200 separate illustrations for this limited animation of the classic *Pinocchio*. Done in pen and watercolor, these detailed comic images were also used for a book that accompanied the animated video. Illustrator: Brian Ajhar; Client: Rabbit Ears Production; Title: *Pinocchio*; Art Director: Paul Elliot.

2 Cable TV has opened up many outlets for animation, and if you are persistent, talented and lucky you just might have a shot at your own TV show or segment. That's how The Simpsons achieved national attention. And now Everett Peck has scored a bullseye with Duckman. Illustrator: Everett Peck; Title: *Duckman*; Art Director: Everett Peck.

3 Peck also rendered the 200 illustrations in ink and watercolor for a limited animation feature. Here he employs his typical " editorial" style. Illustrator: Everett Peck; Client: Rabbit Ears Production; Title: *Mose The Fireman*; Art Director: Paul Elliot.

Corporate

CORPORATE (or institutional) graphics highlight the image or message of a particular company through annual reports or promotions. Such clients are usually conservative, and therefore these projects are often tightly art directed. Corporate work is not merely lucrative, but in many instances creatively satisfying, too.

1 David Plunkert's photo collage for the cover of an annual report borrows imagery and technique from the 1920s Dada movement. The message is humorously appropriate. Illustrator: David Plunkert; Client: The Recording Industry Association of America; Title: *a.r. 93*; Art Director: Neal Ashby.

2 For this corporate brochure, Jean Tuttle has done a computer rendering comprised of various economic tropes: the lightbulb for ideas, the buildings as bar graph lines and the graph itself. Illustrator: Jean Tuttle; Client: Dow Jones/*Barron's Magazine*; Title: The 1994 Roundtable Issues; Art Director: John White.

3 Guy Billout's precise ink and watercolor drawings set the stage for the incongruity found in the almost gamelike images. Here he transforms the delivery truck into a corporate symbol and stretches it into fantastic proportions. Illustrator: Guy Billout; Client: Herman Miller; Title: *Financial Statements of Herman Miller, Inc.;* Art Director: Stephan Frykholn.

4 What better image for an opera company's fund raising brochure than a classical 18th-century court portrait? In this case, the artist is Kinuko Y. Craft, who expertly masters this stylistic recreation. Illustrator: Kinuko Y. Craft; Client: The Washington Opera; Title: *Manon;* Art Director: Clay Freeman.

1

2

3

4

5

6

7

9

10

8

5 Linda Bleck has synthesized expressionistic and cubist approaches in this illustration, rendered in gouache. Illustrator: Linda Bleck; Client: Monterrey University; Title: *Cincuenta Aniversaria*; Art Director: Chris Hill.

6 Raphael Montoliu's straightforward rendering of a business meeting is enhanced by the aerial composition as well as by the stark pen-and-ink engraving style. Illustrator: Raphael Montoliu; Client: Caremark; Title: *Providing Innovative Solutions*; Art Director: Bruce Mikula.

7 By combining two clichés Tim Lewis has created a unique image that conceptually defines "a shrinking planet and a growing market." Illustrator: Tim Lewis; Client: Time Warner; Title: "Globullish"; Art Director: Walter Bernard.

8 Architectural icons often make good graphic images. Mark Harfield has used the computer to compose a farcical image of New York's best-known skyscrapers for a moving announcement. Illustrator: Mark Harfield; Client: VHL International; Title: *New York*; Art Director: Mark Harfield.

9 Paper companies are among the most creative corporations. A Native American in ink and watercolor represents both the corporate and product name. Illustrator: Jack Unruh; Client: Mohawk Paper Mills; Title: *Mohawk*; Art Director: Michael Beirut.

10 The heroic pose is a common trope in contemporary illustration. Here, maximum black and minimum background recall early 20th-century posters. Illustrator: Michael Schwab; Client: B&W Nuclear Technologies; Title: *Nuclear Plant Experience Conference*; Art Director: Richard Gentile.

ILLUMINATED LETTERS have a long history going back to early religious manuscripts. Today illustrators are often called upon to create imaginative letter forms to express more information or emotion than the conventional typeface. Unless, however, one is a "letterer" this is not a profit center, but the occasional illustrated letter is another way of focusing one's talents.

1 Decorative scripts are always in demand to give color and character to an editorial or ad page. Carolyn Fisher's curlicue writing is done in ink and watercolor. Illustrator: Carolyn Fisher; Client: The National Community College Chair Academy; Title: *The Characteristics of a Great Chair*; Art Director: Brad Smith.

2 In the tradition of the illuminated manuscript Kinuko Craft's illustrated "A," rendered in acrylic, is as fully resolved as any narrative or representational picture. In the advertisement in which it was used, it served the function of an illustration. Illustrator: Kinuko Y. Craft; Client: British Airways; Title: *Ad for British Airways*; Art Director: Delores Marcoux, Backer Spielvogel Bates.

3 Informal comic lettering is very visually appealing in advertisements, especially in this case where Hal Mayforth introduces a comic character, too. Illustrator: Hal Mayforth; Client: *Newsweek*; Title: Special 90s Extravaganza; Art Director: Lisa Michurski.

4 This pen and ink illustrated alphabet done in a modernistic style by Jeanne Fisher might have been used to add another dimension to an otherwise text-heavy article. Illustrator: Jeanne Fisher; Client: Jeanne Fisher; Title: *Alphabet*; Art Director: Jeanne Fisher.

1

2

3

4

LIKE BOOKS record packaging has been fertile ground for illustration. Since the CD digipack has replaced the 33⅓ rd record sleeve the posterlike area has been diminished, but illustrators are still in demand.

1 Frank Viva uses the computer to achieve this abstract, virtually carved effect to illustrate a CD of avant garde saxophone music. Illustrator: Frank Viva; Client: RSM Records; Title: *Saxart Sees The World*; Art Director: Frank Viva.

2 Laura Levine's primitive portraits rendered in gouache were a smart choice for a series of CDs of Blues greats. The series and the specific subjects are immediately recognizable. Illustrator: Laura Levine; Client: Verve/Polygram Records; Titles: *Louis Armstrong,Ella Fitzgerald*; Art Director: Alli Truch.

3 Mark Ryden's fantasmagoric, symbolic composition painted in oil on canvas is a remarkably obsessive interpretation of a bestselling pop record album. Illustrator: Mark Ryden; Client: Sony Music; Title: *Michael Jackson, Dangerous*; Art Director: Nancy Donals.

4 Everett Peck comically interprets the title of this CD with his caricature of a gagged diva rendered in gouache. Illustrator: Everett Peck; Client: London Records; Title: *Opera Without Singing*.

5 This collage of drawing and photography is Hieronymus Bosch-like in its eerie representation of a mass murder. Illustrator: Jonathon Rosen; Client: Point Records; Title: *The Manson Family, An Opera*; Art Director: Marjorie Greenspan.

Good MEDICAL illustration can be as life enhancing as a good medical procedure. Doctors and nurses learn as much from the anatomical renderings in their texts and charts as they do from actual anatomies. The skill needed for this line of work far exceeds all other genres of illustration.

1 To accurately render the nerve and circulatory system in the face and head requires an expert knowledge of anatomical workings, often learned by dissecting the body itself. Illustrator: Carlos Lacamara; Client: Zinnanti Surgical Laboratories; Title: *Basic Veins and Vases of the Head*; Art Director: Carlos Lacamara.

2 Bill Andrews' pen and ink rendering is a vivid lesson in how to repair a life-threatening aneurysm. This textbook drawing is accompanied by a detailed caption. Illustrator: Bill Andrews; Client: Denton A. Cooley, M.D.; Title: *Endoaneurysmorrhaphy*; Art Director: Bill Andrews.

3 This more conceptual illustration painted with acrylic is not used for training but is vivid enough to introduce the reader to the treatment of malignancies in HIV-infected patients. Illustrator: Keith Kasnot; Client: *American Family Physician Magazine*; Title: "Malignancies in HIV-infected Patients"; Art Director: Kathy Gannon.

1

2

3

4

5

4 William Westwood's precise pencil drawing of a medical procedure shows the placement of the scalpel and clamps. Illustrator: William Westwood; Client: Learning Technologies; Title: *Pectoralis Minor Muscle*; Art Director: Bill Westwood.

5 The overview and the detail are typical ways of visually describing anatomical parts. This painting in acrylic and airbrush of the heart and its valves helps the doctor identify vital internal organs. Illustrator: John Karapelon; Client: *Bicycling Magazine*/Rodale Press; Title: *Magic in the Air;* Art director: Ken Palumbo.

6 What appears to be a galaxy in a sci-fi painting is a super-magnified detail of the basal ganglia of the brain. Illustrator: Christine D. Young; Client: Eli Lilly and Company; Title: *Dopamine Agonist;* Art Director: Christine D. Young.

6

Packaging

THIS IS NOT A typically rich area for illustrators, but more and more packaging for clothes, food and electronics are being illustrated.

1 Bob James weds scratchboard drawing, lettering, and design to create a label and an unusual identity for a jeans company. Illustrator: Bob James; Client: Britches; Title: *Warthog*; Art Director: Gregg Glaviano.

2 Ann Field's delightful packaging for this panettone combines an image of the traditional Italian cake with contemporary carnival-like graphics. Illustrator: Ann Field; Client: Macy's; Title: *Mia Cucina*; Art Director: Teresa Steuer.

3 Batman didn't just grow under a cabbage leaf, he is created by artists. This product uses a current rendition of the caped crusader illustrated in a noir style to introduce a pasta product shaped in his image. Illustrator: Leif Peng; Client: Heinz Foods; Title: *Batman Pasta*; Art Director: Dawn Lampert. Batman and all related elements are the property of DC comics Inc. ™ and © 1992. All Rights Reserved.

4 More and more national brands are being given updated trade dress. Jean Tuttle's contemporary renderings for this beverage give it eye, if not appetite appeal. Illustrator: Jean Tuttle; Client: Moosehead Breweries Ltd.; Title: *Mooselight*; Art Director: Bob Goulart.

5 Edward Parker employs a homestyle approach, painted in acrylic on masonite, to suggest the kitchen fresh quality of this food product. Illustrator: Edward Parker; Client: Kraft Foods; Title: *Kraft Mayonnaise Anniversary*; Art Director: Kathleen Kasca.

1

2

3

4

5

WHAT RECENT graduate of art school doesn't dream of becoming a cartoonist? Although there are some jobs in the mainstream comic industry, most comics artists do this work as a sideline.

1 Everett Peck created porky as the protagonist of his strip about urban life drawn in pen and ink. Illustrator: Everett Peck; Title: *Porky's Auto Body*; Art Director: Everett Peck.

2 Peter Kuper's strip, a satiric look at the reality of warfare, is rendered by spraying airbrush through stencils. Illustrator: Peter Kuper; Client: *Heavy Metal*; Title: "Bombs Away"; Art Director: Peter Kuper.

3 Julian Allen illustrated Bruce Wagner's story in a comic strip form using detailed ink and charcoal pencil renderings. Illustrator: Julian Allen; Client: *Details*; Title: "Cul-De-Sac"; Art Director: B.W. Honeycutt.

4 For the cover of his comic book Jonathon Rosen creates a parody of a typical sex magazine using muted, earth colors and bright reds to accentuate the erotic mystery. Illustrator: Jonathon Rosen; Client: Fantagraphics Books; Title: *Snake Eyes*; Art Director: Jonathon Rosen.

5 Borrowing from 1940s noir films David Mazzuchelli creates a comic page that focuses not on the characters but the details of their detective trade. Illustrator: David Mazzuchelli; Client: *Snake Eyes #3*; Title: "Phobia".

Science

SCIENTIFIC illustrations are often used for text books and other technical materials, but can be found in editorial and advertising contexts as well. While some artists specialize in this field, other hyper-realists work well in both this and others.

1 Marc Hess' rendering in acrylic of this prehistoric scene is totally credible from the representation of the dinosaurs to the landscape on which they roam. Illustrator: Mark Hess; Client: *Newsweek*; Title: "Gentle Giants"; Art Director: Ron Myerson.

2 Biologists require very accurate schematics of the natural surroundings. Rolin Graphics uses ink and watercolor in their depiction. Illustrator: Rolin Graphics; Client; McGraw Hill; Title: *Nature of Life*.

3 To visualize how one sees using the left and right brain Jane Hurd has superimposed the biological function on a portrait of a child using acrylic (airbrush & sable brush) on bristol board. Illustrator: Jane Hurd; Client: National Geographic Society; Title: *Anatomy of Vision*; Art Director: Ursula Vosseler.

Radial canal

Tube foot

Coelomic cavity

Sieve plate

Ring canal

Gonad

Digestive gland

[A] A sea star

Anus

5 "Hearts"

Crop

Gizzard

Brain

Mouth

Blood vessel

Nerve cord

Body cavity

Intestine

[A] An earthworm

Partitions (septa)

Excretory units (nephridia)

Intestine

Funnel

Nerve cord

Excretory pores

Bristles (setae)

[B] A segment

4 Insects are but one of the many themes that recur in scientific illustration. Rolin Graphics uses acrylic and airbrush to get their realistic effects. Illustrator: Rolin Graphics; Client: McGraw Hill; Title: *Nature of Life*.

5 A simple painting of a bird on a finger requires considerable skill and knowledge when done for a science reference. Illustrator: Carlyn Iverson; Title: *Male Golden-crowned Kinglet*; Art Director: Carlyn Iverson.

6 To provide accurate visual data, scientific illustrators must learn everything there is to know about their subjects. This acrylic rendering of a lizard, inside and out, is an example of just such a mastery. Illustrator: Keith Kasnot; Client: Prentice Hall Publishing Company; Title: *Evolution: Change Over Time*; Art Director: Ann Marie Roselli.

7 Like the 19th-century masters, botanical illustration is not simply a matter of rendering pretty flowers, but of presenting a historical picture of rare and common plants. Roberta Rosenthal's gouache is an excellent example of the skill needed to make two-dimensional renderings come alive. Illustrator: Roberta Rosenthal; Client: *Horticulture Magazine*; Title: *Crocosmia Masonorum*; Art Director: Sarah Boorstyn Schwartz.

IN RECENT YEARS visualizing the vast amounts of information presented daily has become an artistic as well as editorial problem. Illustrators are often called upon to mediate as much as decorate information graphics.

1 Steve Carver has used mixed media to convey the key sights in one of Paris' historical districts. Illustrator: Steve Carver; Client: American Express/*Departures Magazine*; Title: Le Marais; Art Director: Bernard Scharf.

2 Cross sections are standard fare for info graphics. Being able to clearly illustrate difficult information is a great skill. Like many info artists, Scott MacNeil uses the computer to address complex information; Illustrator: Scot MacNeil; Client: Sussex Publishers/*Mother Earth News*; Title: "Building a Wood Box"; Art Director: Rob George.

3 An otherwise boring map can be enhanced through comic decoration. Marc Rosenthal draws his witty frame in ink and watercolor. Illustrator: Marc Rosenthal; Client: Physicians Health Services; Title: *Legwork*; Art Director: Bob Manley.

4 Purely technical info graphics are important to the smooth flow of information. Christoph Blumrich's diagram of the brain is but one example of no-nonsense illustration. Illustrator: Christoph Blumrich; Client: *Newsweek*; Title: "Mapping the Mind." Art Director: Patricia Bradbury.

5 Rodica Prato employs the map as a metaphor for the new world of electronic systems. This ink and watercolor rendering recreates the look of antique maps. Illustrator: Rodica Prato; Client: Control Data; Title: *Journey to the New World*; Art Director: John Montgomery.

1

2

3

Mapping the Mind

Personality traits from shyness to impulsivity, scientists believe, are produced by particular brain molecules acting on specific brain structures. Through brain-mapping and biochemistry, researchers have identified some of them:

4

5

JOURNEY TO THE NEW WORLD

1

2

3

4

5

In addition to all the formal genres, illustrators are called upon by advertising agencies, design firms and corporate art departments to render images for a large variety of products, displays and promotions. Here are a few.

1 Richard McGuire decided the world needed another game of Go Fish and proceeded to not only design his own, but market and sell it, too. The artwork was done in ink with color added on overlays. Illustrator: Richard McGuire; Client: McGuire Toys Inc.; Title: *Go Fish*; Art Director: Richard McGuire.

2 The illustrated umbrella is one way to give a new dimension to this quite utilitarian object. Illustrator: Julia Gran; Client: How Charming Productions; Title: *Soaked to the Gills*; Art Director: Connie Sherman.

3 Illustrated shopping bags are very popular advertising vehicles as well as great canvases for illustrators. Illustrator: Gary Baseman; Client: Bloomingdale's; Title: *New Year's Shopping Bag*; Art Director: Todd Waterbury.

4 The illustrator as muralist is not uncommon. This decoratively designed scene becomes a focal point in one of the busy departments of a major retail store. Illustrator: Anne Field; Client: Barneys; Title: *Mural for Men's Store*; Art Director: Simon Doonan.

5 Postage stamps are the smallest of posters and illustrators who can adapt to the lilliputian dimensions have the chance to create some very high-visibility work. Illustrator: Braldt Bralds; Client: United Nations Postal Administration; Title: *Climate Environment Issue*; Art Director: Rocco Caccari.

On Being an Illustrator

If education is equal parts learning and experience, then the best educators are those who have learned through experience. Illustration is a quirky field with few set rules governing how one becomes, and ultimately remains, a practitioner. Sometimes one walks in through the backdoor—as a painter looking for more professional status or as a designer wanting to paint. More commonly, one enters through the front door—going to art school or knowing that one wants illustration to be the primary occupation. Either way, the wannabe has many doors to choose from.

This section addresses the individual experiences of eleven veterans representing vastly different backgrounds, age groups, styles, techniques and points of view. The only common threads are that all are passionate about making images and none were schooled in the business of illustration. In addition to asking what motivated them to become illustrators in the first place, what levels of art education they received and who were their mentors and influences, these interviews explore their business sensibilities: How are their studios organized? How do they promote themselves? Do they have an artist's representative? What are their thoughts about pricing, client/artist relationships and professional ethics?

The questions in these interviews are designed to give the reader a general picture of their practices, with emphasis on how they have established their business, how they work with their clients, how they wed their professional and personal lives and how they feel about the future of their profession. The responses are varied and diverse. Some typically avoid business in the strictest sense, others uncharacteristically embrace it. Some find artist representation essential, others prefer direct contact with clients. A few do not promote themselves, others are active in their self-publicity. Some believe that illustration fees are fair, while others insist they are not, and have never been, commensurate with their labor. All concur that the freelance life can be lonely and isolating, but all agree that they made the right career choice. As illustrators they follow their muses, perfect their skills and build on talents that bring them great satisfaction.

ALAN E. COBER

Alan E. Cober has had work produced in major magazines and commissioned by many of the Fortune 500 corporations. Among his commissions have been covers for *Time* and *Newsweek*, Bicentennial posters for the National Parks Service and a mural for the National Museum of American History for George Washington's 250th birthday. He has covered the 1980 presidential campaign for *Time*, lift-offs from Cape Canaveral for NASA and the Pope's U.S. tour in 1987 for *Rolling Stone*. His essays on Willowbrook, the New York State institution for mental health, have been compiled in his book of drawings, *The Forgotten Society*. Professor of Art and Distinguished Visiting Artist at the University of Buffalo, State University of New York, Cober has also won numerous awards.

How did you become an illustrator?
I was supposed to be a lawyer—my father was a criminal lawyer—so I studied Business Administration at the University of Vermont. But I'd also always wanted to be an artist, from the time I was a small child. I had an uncle who was an artist. After two years at the University of Vermont, I went to the School of Visual Arts from about '54 to '56. I came out of school wanting to be a men's fashion illustrator and somebody gave me space in a men's fashion studio, they thought I was good enough. After about six months I realized they were trying to turn my work into stone, and I really wanted to do journal-

Client: Title: *Pig Head*; *The Georgia Review*; Art Director: Ron Arnholm.

ism. I was too late for that because photography and television had already made inroads, it was past its prime. But I still consider myself a visual journalist.

Did you have any mentors?
Albert Werner was my professor and my mentor. He made me who I was. He made me a man.

How are you set up in terms of business?
I have a studio in my barn and in my house. I have another studio in Cape Cod, and I have a studio where I teach. I usually print in the barn now, and work in the house because it's easier for me. I don't have a copier. I don't have a computer. I have a fax machine and a Panasonic auto-stop pencil sharpener.

Who does your bookkeeping?
I keep track of jobs in a ledger. I know when I got the job, the account and what job it is. My next job will be #2200; I have every job numbered since the day I started. The job numbers are really for me, I don't even put them on my bills. When I get paid, I enter it, but the real accounting is done by a CPA. I do all my own billing

as I do my own Federal Express packages.

Have you ever had an assistant?
I had an assistant for about six months in 1974, George Angelini. George does a lot of portraits for *Reader's Digest*. He's the only assistant I've ever had. The problem is what do I do with an assistant if I'm not here? And I'm not here a lot.

When did you first start teaching?
I first taught drawing at the Silvermine College of Art, near New Canaan, Connecticut, in 1966-67. Two years later, I taught at Parsons. I didn't like it there because the students weren't working. I told them "If you come in next week and you don't have the work, I'm not coming in the following week." So they came in and they didn't have the work, so I quit. In 1973, 1974, we started to do the Illustrators' Workshops. I was chairman. In 1987 I began teaching one day a week at the University of Buffalo, State University of New York. Soon after, I became fulltime. Now I'm there two days a week.

Do you enjoy teaching?
I enjoy teaching. I had a good teacher and he made an impact on me. He taught me the value of hard work and to be good. Sometimes it's very difficult and sometimes there's a lot of guilt that goes along with teaching, because you've got a lot of people who probably won't be able to make it as an illustrator. I always say to the class at the beginning, "Look, not everybody in this class is going to end up as an illustrator. Some of you will be designers, some of you will be art directors, some of you will be production people and then some of you will sell shoes. It's that simple." On the other hand, there are people who develop later rather than sooner, and those are the wonderful surprises. I've got a student in my class now who'd had the reputation of being lazy, and never coming to class. Last year, in my thematic class, he started doing great drawings and he was my

star. I use him as a prime example of what people should be doing in the class. He worked very hard, he went and drew old folks. This year we've done one assignment and his was by far the best. So life is filled with surprises when you're teaching. And lots of disappointments, too. You just do the best you can to keep them going and make them work. When they miss an assignment, I always tell them, "you're not doing it for me. You're doing it for yourself. And if I say to do one, you should be doing five."

What are your thoughts on education today?
There are certain things that are a must. One is drawing. When I teach my drawing class, I stress the way they use the page. The same with doing their portraits. I see a guy doing a head in the middle of the

Client: *New York* magazine; Art Director: Robert Best.

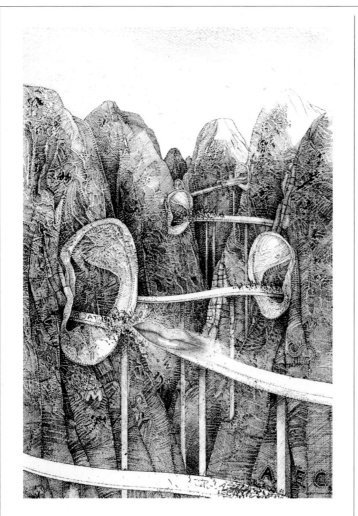

Well, first of all, there's much more competition today. But, on the other hand, when I got out of school, there was no field for what I did. I got a spread in *Sports Illustrated*, and also a spread in *Redbook*. Those two magazines were a big deal. By 1964, I had done five issues of *Redbook*. The following year, I did five spreads in *Ladies Home Journal*. All of a sudden, I was hot and I was only twenty-eight years old.

What are your thoughts on self-promotion?

I'm good at creating it but not sending out. I have promos and I use them when I send out the portfolio. Sometimes along with the finished artwork for an assignment, I'll send out a batch of tearsheets. But that's about it.

Have you ever had a rep?

I had three. One for about a year. I was with Cullen Rapp for thirteen years. Cullen looked at me as an artist and he called me an illustrator's illustrator. But when young Jerry Rapp came in, he brought in a guy that was in direct competition with me. I thought that was not politically correct. I'm still friends with Jerry, he just did something that was against my rules. So I split and went to Harvey Kahn. He was the best rep at that time. I stayed with

(Above) Title: *Smooth Talk*; Client: Neenah Paper; Art Director: Brad Copland. (Right) Title: *Self Portrait with Crab*; Client: *The Georgia Review*; Art Director: Ron Arnholm.

page, they're not using the space. They haven't the vaguest idea what I'm talking about. They're not designing the page. So the most important thing is drawing, including how you use the space on the page and how well you see. And then, to learn to use color. That can come later, as it did for me. I tell students, "To be a good illustrator, you first have to be a good artist." You have to study art and the history of art. You've got to have it all. There's no hiding. There are no abstract expressionist illustrators, they all have to know how to draw. There are people who do collage, but that's today—next week they'll be going back to drawing.

him for eleven years. We split. I started developing a campaign in *Showcase*, called "Corporate Cober." I thought that people knew me as an editorial artist and what I was trying to say to them was this editorial artist is also a corporate artist. Well, within two years I tripled my income.

How does one go about choosing a rep?
The first thing one would have to do is find somebody who relates to their work. That's the most important thing. Someone who's enthusiastic. Then what kind of business person are they? What do they know about the business? What kind of deal are you going to get? Who else do they rep? Are there any conflicts? Maybe business comes first with enthusiasm for your work.

What are the advantages to having a rep?
Is there any advantage? I guess for some people the main reason they would need a rep is pricing. It's hard even for me to negotiate and price. It's hard for anybody. You've got to know when to say how much and you've got to know how far you can push it, and when to back off. The main thing is if you can learn that part then you don't need a rep. You can do what any rep does: they put an ad in *Showcase*, and they wait for the phone to ring. Now I've even gone a step further, I've decided I'm going to put myself in *Stock Illustration*. Some of those things have sold a dozen times or

more. If a client is willing and it's not a problem for them, why not.

This whole area of second rights and selling stock illustration is really taking off these days.
I've been selling stock illustration for the last six or seven years. Nowadays, when someone calls me for a job that is not paying very well, I ask myself, "If I do this thing, is it the kind of drawing that I can resell? How can I make this work for this client and also make it work for me later? Is it worth it for me to do it?"

What is it that you like about the business that keeps you going?
I don't love illustration as much as I used to. I think a lot of the field has changed. It's changed because the editors have taken the reigns away from the art directors. The editors have taken the responsibility away from the art directors and are making all the graphic decisions. They want everything to look like a gag cartoon. They want everything to be captioned. The problem so often is that you have to deal with young art directors. They call you to do a job and the editor has the idea. It's a terrible idea. But the editor is pulling this person around by the nose. You've become an extension of the art director, so you're a nobody, which is totally unacceptable.

(Top) Title: "Successful Money Management Using Multiple Styles and Strategies"; Client: Pacific Mutual Insurance; Art Director: Doug Joseph. (Bottom) Title: "Providing Financial Security for Our Clients"; Client: Pacific Mutual Insurance; Art Director: Doug Joseph. (Left) Title: *Ma Porpoise Meets Mr. Alligator*; Client: Louisville Art Directors; Art Director: Sheri Squires.

BRAD HOLLAND

Brad Holland is self-taught and has worked professionally since the age of seventeen. At twenty-four, he began writing and drawing for such underground newspapers as *Screw*, *Rat* and *The New York Ace*. In 1971 he was one of the founding artists of the Op-Ed page of *The New York Times*. His work has appeared in nearly every major U.S. and many international publications, including *Playboy*, *The New Yorker*, *Time*, *Newsweek*, *The Atlantic Monthly*, *The New York Times* and *Frankfurter Allgemeine Magazine*.

When did you start drawing?
I must have been issued Crayolas when I was born. I remember doing comic strips when I was four. My mother had a drawer full of old greeting cards people had sent her, and I used to take them and open them up, and use the backs of them to draw on.

So you knew that was the direction you wanted to head in at an early point?
No. There were lots of things I wanted to do. All through high school, I wanted to write comedy. I thought I'd go to New York and write for The Gary Moore Show or The Honeymooners.

So, you never really gave much thought to making it a profession? The drawing aspect?
Well, I came from a family where nobody's ever gone to college. There were no pictures on the walls. There were no

records, no books. You were a big deal in town if you became a tool and die maker. I didn't know how artists earned a living. Well, doing comic strips could lead you into writing or drawing or into making movies. And I decided before I left high-school, that I wanted to do something where I could make a living on my own and not ask anybody for money.

You didn't study art?
No.

Was it an intentional decision?
Well, yes and no. I didn't really want to go to art school. But I didn't have any money anyway, so it wasn't a decision that required any effort.

What made you think you didn't want to go to art school?
I suppose I sound very cocksure about it now. At the time I was only semi-cocksure. It didn't seem to me they were teaching art at art school. Just a little art history and a lot of theory. Also, a lot of the classes seemed to be there just so the instructors would have jobs. And since people were going to art school to learn how to make a living, that wasn't a good sign.

How did you know, or how did you think you knew, what art schools were like?
When I moved to Chicago I had some

Title: *The Steps to the Steps*; Client: *Best of Business.*

friends at the Art Institute. They were freshman. Studying fine art. And all their professors were going on about how they had to develop a style. You know, a year before these guys were drawing hot rods and super heroes, now in four years they're all suposed to have original styles. So all those kids were whizzing around looking for gimmicks to call their style. Like "I wrap everything in tin foil, that's my style" or "I make American flags out of fur", you know, to symbolize our aggression in Vietnam, or something. It's no wonder most people think of the art world as a clown show. Meanwhile these same professors were telling their students that it's impossible to do any good work in commercial art. I always wished I could watch them try to explain that to Duke Ellington or George Gershwin. I left for Chicago the summer after high school. I was wearing a band jacket. I had a handful of drawings in an envelope and $125 I had saved mowing lawns. I didn't know very much, but I knew vaguely what I wanted to do. Everybody who was cool said that representational art was either dead or camp. That meant abstract art or pop art, and I had no interest in that. I suppose I wanted to turn the same feelings into pictures that I'd have turned into plays. That kind of thing had been banished from art by the avant garde. They called it literary art, and it was supposed to not be pure. The problem on the other side was that illustration was so flat-footed. Everything was literal and representational. There was so little invention or anything personal. There was no expression of form. Nothing ever

came out of left field. Anyway, I needed to earn a living, so I just kind of blundered into this job at the studio.

When did you go off on your own as a freelance illustrator?
A couple of years later. I came to New York on a bus.

Did you know anybody in New York?
No. It was just like leaving for Chicago except I had a little more money. I'd saved a thousand bucks, and I had a portfolio and a suitcase. I got off at Grand Central Station and took the portfolio to Herb Lubalin's studio. Then I went to find Greenwich Village in case I wanted to live there.

How did you fare with Lubalin?
He gave me a double-page spread to do in the first issue of *Avant-Garde*. He asked me where my studio was, and I said "I've got a locker at Grand Central Station." He asked how long I'd been in town, and I asked him what time it was. I'd been in town about three or four hours. The next day I went to Doubleday and got three books to illustrate from Alex Gotfried. Then I went to *Playboy* and got a double-

Title: *Three Dogs;* Client: *Frankfurter Allgemeine Zeitung;* Art Director: Hans-Georg Popischl.

page spread to do for them. Plus, they asked if I wanted to do work every month.

No kidding. Well, you certainly didn't waste any time.
Well, I couldn't afford to waste time. I had to make it before my thousand dollars ran out. But I was really eager. I finished the job for Lubalin in two days. I bought my art supplies at a five-and-ten in Times Square, and I did the work on the floor of a room in the Taft Hotel. The next week I found an even cheaper hotel, a fleabag called the Collingwood on 35th Street, where they rented rooms by the day or the hour. I got my room at a discount because there was no lock on the door. Every night I rammed the bed against the door and then a chest of drawers against the bed, so anybody breaking in would have to wake me up. I was always getting phone calls for prostitutes.

On a related subject, have you ever had a rep?
No. I talked to several when I started but they all wanted me to change what I was doing. Then when I became successful, a lot of them called wanting to rep me. But most of them still wanted me to change. Anyway, I was happy running my own affairs by then. Back when I was just barely scraping by some rep promised he'd get me $100,000 a year if I'd quit doing the kind of work I was doing and do what I was capable of. That was the way he put it.

Was that advertising?
Yeah.

Do you do much advertising now?
Yeah. But most of the people who call me now usually want me on my terms. I couldn't have gotten that years ago.

Do you approach advertising differently from your other work?
No. Except you can't put a lot of fire into a picture for an ad. I want advertising pictures to be cool. Cerebral. Ironic. Detached. That's why I have to do other stuff. You have to have some place to really put your talent.

Are you anti-business?
No. And I get tired of listening to artists rant about how business eats the soul. Narcissism eats the soul too. So does filling out forms for grants.

Obviously you're at a point where you have so much control over what you do, you really don't do anything that doesn't interest you.
Basically. But that's a deceptive answer. My problem is it's very easy to get me interested in something. If somebody calls up and says "we're doing a book about porcupines", I'll think, "Hmm, porcupines! That sounds interesting."

Are you incorporated?
No. I was once. I was a Delaware corporation. I felt like a bank. I had a little corporate seal and everything. Then they changed the tax laws, so I unincorporated.

How is your business set up? Do you

have an accountant? Do you keep books? Do you have a bookkeeper?

Nope. I have an accountant who does my taxes. That's it. I used to just have a big cardboard box, and anything related to business, I threw into the box. Then at the end of the year, I'd dump it out on the floor and root through it and put things in piles to take it all in. Now I have an assistant who sorts through things on a daily basis.

So, your assistant does what kind of work for you?

She writes letters for me. She does almost all my bookkeeping, such as it is. She arranges my schedules, faxes, types. She's very fast. Her main job is to keep me from distracting her.

What kind of equipment do you need for your studio to set up? Do you have a computer?

Yeah. Sanna uses it. But I'm still like those apes in 2001. You know, where they're inspecting the monolith. I run up and touch it and then jump back. I haven't found anything yet that I can do with a computer that I can't do without it. People are always telling me you can keep your books on a computer or make lists. But I can make a list on the back of an envelope. Or computer artists say things like, "Look! You can get this pastel effect with a computer." But I can get a pastel effect with a box of pastels.

Do you have a copier and a fax?

Yep.

What else do you need that you use in your studio?

Well I'm doing a lot of work overseas. I probably ought to get a bunch of wristwatches and set them to all different times. Otherwise, I don't really need very much.

Do you ever do any self-promotion?

No. I've never even had business cards or

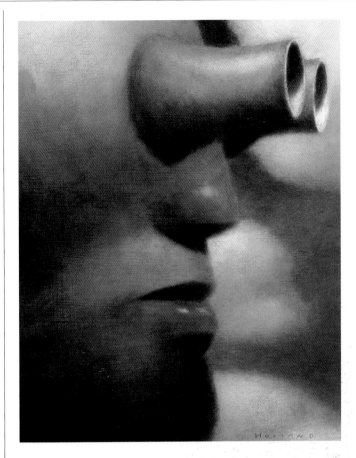

Title: *Tunnel Vision;* Client: *Science* magazine; Art Director: Wayne Fitzpatrick.

stationery. Years ago I had a couple of friends who were junkies and I took my number out of the phone book so they couldn't find me. Since then I haven't been listed in the phone book.

But how do art directors find you?

I've never asked them. Different ways, I suppose.

Have you ever paid to be in a promo book?

No.

What about illustration annuals, like the Society of Illustrators?

I've always used them. As I said, when I broke into the business, agents wouldn't rep me. So I used those books to get my work seen. Twenty years ago, almost the only ones around were the *CA Annual* and the *Society of Illustrators Yearbook*. You know, it was a very different business

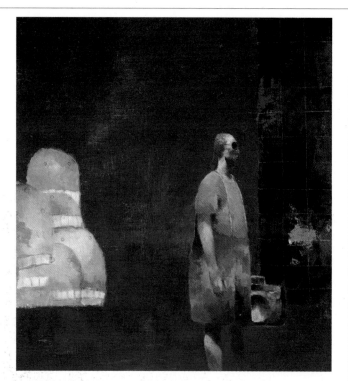

Title: *Subterranean;* Client: *Frankfurter Allgemeine Zeitung;* Art Director: Hans-Georg Popischl.

then. Mostly a business of middle-aged people who used those annuals to pat each other on the back at the end of the year. But I was very young and I wasn't part of any of that. So I entered all this stuff into their books, published and unpublished, to get exposure.

You've had a number of imitators. How do you feel about them?
Well, some of them are better than others.

Nothing else you want to say?
Well, anything else I say will be misunderstood. It's a funny feeling. I'll pick up a magazine and see a picture of some little guy pushing a big dollar sign up a hill or something like that. It looks like I did it only it's not the kind of thing I do. Not that kind of obvious, clumsy symbolism. But it has the color, and the look, even the feel of something I'd do. I think it rings false because imitators pick up on your flaws. Your flaws are the most imitateable thing about your work, the easiest thing to identify. Pretty soon you've got editors calling, and they want something just like it.

Is that why you've changed your style so often?
No, my model was always writers, guys who could write essays, poetry, plays, whatever they chose, and try different approaches. I mean, you can't get everything into a single picture. Every picture is just a piece of a whole.

How do you deal with contracts? Do you negotiate them yourself?
I have an evil twin who writes my contracts for me.

So you're good at it?
My favorite adventures in contract law always seemed to involve my old archenemy, CBS Records. The CBS lawyers had this imperious contract that entitled them to your work "forever and in perpetuity for all media now known or yet to be invented."

So would you sign a contract like that?
Not without a ton of money, no. So I usually spent two-thirds of each job with me and lawyers circling each other. When I did an album cover for Billy Joel, CBS wouldn't even talk to me. I had to deal with his law firm, Grubman and Grubman. Could you invent a better name for a law firm?

How did that work out?
Same as usual. We spent weeks haggling. Then I had to do the cover overnight. At one point, just before the end, I told one of the Grubmans they were going to have to print the contract on the cover because there wasn't going to be enough time left to do a painting.

How do you deal with copyrights? Do you keep the copyrights to all your work?
For enough money I can be talked out of one here or there.

In terms of dealing with art directors, are there certain problems that you see

right away, or that you think could be improved upon? Some illustrators have said they don't get any feedback at all after they've sent a piece in. And I find that amazing.

Yeah, that happens a lot.

Some illustrators say it drives them crazy and other illustrators say, "Oh, that's the business. I know art directors are busy."

I'm in the latter category. Artists are all so hypersensitive. I just do work to please myself. If somebody else likes it, great. But either way the job's over, you go on.

So you don't dwell on a job after it's finished?

No. This kind of work is like a performance. You do the best you can, you put your heart into it. Here's how much time you've got. Here's how much energy. The picture's got to fit into this space. Then it's over. If you're lucky you'll have another shot at something else.

How has the business changed since you started?

Well, the biggest change has been in the way show business has swallowed print. When I started print still validated enter-

tainment. If some movie star became famous enough they might put him on a *Time* cover. Now entertainment validates print and magazines will use any excuse they can think of to fill up their pages with celebrities.

How has that affected illustration?

It's given work to a lot of really good caricaturists, that's one thing.

Has it affected you in any particular way?

Not really, but it's changed the tone. When I broke in all the art directors and editors were

like Lou Grant. They were much older than I was and they were print people, so I always had to prove myself to them before they'd give me the room to do something different or odd. They'd growl and ask what some picture was supposed to be saying, but in the end, a lot of them would support you, or at least give you enough rope to hang yourself. Now my generation's in charge and there's a lot more freedom, but there's also a kind of hip cynicism. People my age really fell for that "Medium is the Message" stuff, like it doesn't matter what you say, it's all technique anyway. Everybody's a spin doctor now. There's so much self-consciousness. It's a hall of mirrors.

What's the most fulfilling thing about working as an illustrator? What is it that pleases you the most about what you do?

What's most satisfying to me is turning in some job after a tight deadline, then you pick up a magazine a couple weeks later and there it is and it's almost exactly the picture you saw in your head when you first conceived it.

(Above) Title: *Red Poolroom;* Client: *Frankfurter Allgemeine Zeitung;* Art Director: Hans-Georg Popischl. (Left) Title: *Shirts and Skins;* Client: *Frankfurter Allgemeine Zeitung;* Art Director: Hans-Georg Popischl.

MARSHALL ARISMAN

Marshall Arisman was born in Jamestown, New York, in 1938, and graduated from Pratt Institute in 1960. In 1964 he joined the faculty of the School of Visual Arts and is currently chairman of its Illustration as Visual Essay M.F.A. program. He is a regular contributor to the *The New York Times*, *Penthouse*, *Omni*, *Harper's*, *Time* and other publications. His paintings are frequently exhibited.

How did you start your career as an illustrator?

I worked in an art store two days a week. My apartment was forty bucks a month. And at that time, you could do anything in New York without having a full-time job. One of the great dilemmas of the moment is that, in order to exist, people have to take full-time jobs. And then you have no time. But in 1963, you could buy a life by working two days a week doing anything, whatever. And at that time, it was quite easy to see art directors. I'm not sure that that helped in getting any more work, but I think one of the dilemmas now is that you never see anybody. In the beginning, you need to feel that someone cares.

How did you prepare for the problems of selling yourself?

Without knowing how to draw or paint, I developed a style. What I really did was rip it off. I looked around and found people working in illustration that I didn't think could draw either. I think the first year I made $3000. I didn't have a telephone. I had a married friend down the block who had a phone. I didn't know about printing cards. I handmade every card. Every night, when I was freelancing, I would come home and do a little drawing on my cards, give them out the next day, go

home the next night and make more. I had no business sense at all. The funny thing was for my first job my friend's wife picked up the phone, told the art director to hold on and ran down the block to get me.

And did you succeed?

The first year I made $3,000; the second year I made $3,000; the third year I made $2,800. Then I decided that I had failed at illustration. Remember, I was going out at least three days a week, dropping off the book and seeing people. I thought that getting into the Society of Illustrators Show would help. And the third year I

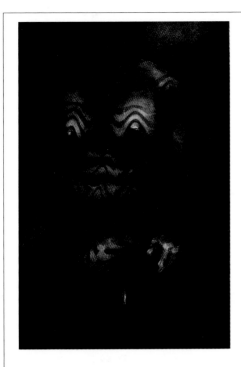

got into the Society of Illustrators, but nothing happened.

The fact that you got in was an accomplishment?
I thought it would change something, but it didn't. So at the end of the two years I quit illustration. I took a job teaching illustration at the School of Visual Arts. I decided that it was time to learn how to draw, so I took a year and taught myself how to draw. My ex-rep in illustration opened a little gallery and had an exhibition of all these drawings. I thought at that time, if I got a good review from *The New York Times* and we sold the drawings that I could have a fine arts career. We sold all the drawings, cheap, and I got a good review in the *Times*. I had been trying to get into *Playboy* for three years as an illustrator. When I sent them an invitation to this drawing exhibition, they called to offer me a commercial job because I was a fine artist. I was totally confused.

Did that start the ball rolling towards a satisfying career?
I decided that I was never going to make any money in this business, so I might as well do drawings about things that I knew something about. I was brought up with a lot of guns, so I decided to do four or five drawings about handguns. A year later I had fifty drawings about guns, which became a book. I sent to a bunch of copies to art directors and suddenly I started getting illustration work. Without this book, this never would have happened, and yet if I had done this as a business venture, I would have tried to out-think it. What the book did was categorize me as somebody who deals with violence, and that's gone on for thirty years.

How do you feel about being pigeonholed?
All of the work I get is editorial and tends to be about unpleasant things. I find that the topics are so outrageous that I get a lot of freedom.

So you're happy being a specialist?
I have great admiration for pros. You can give them almost anything, and they will do a really good job. I'm somebody who, because of my nervous system, if I don't like what I'm doing, I do bad work. So it isn't a hierarchy of principle that runs me. It's that it is a pain for me to do this work, and the work in the end is so bad that it just simply isn't worth it. So without a rep and all that stuff, I end up getting—and this has been true for the last four years—an average of one job a month.

Do you follow any professional standard practices or are you an unashamed maverick?
I belong in the Graphic Artists Guild, but I'm their nightmare. I work on spec, don't work with purchase orders, will make almost every agreement orally and have no idea about kill fees. I won't do sketches but will do finishes as sketches. Part of that is recognizing how I work. Because I work with my hands, and

not brushes (I paint with my fingers), I don't have total control of what I'm doing. I can do a sketch in pencil and then not be able to paint it. So if I get really pushed into having to do a sketch first, and I'm really nervous about it, I will do the finished and then sketch it and turn in the sketch.

Do you encourage students to do as you do?
Nobody's ever cheated me. The only people who haven't paid me are galleries. I keep watching students get into this mode

some brushes were at home, some were at the studio—it just got too complicated. I'm still fighting getting a fax machine. I have an unlisted number in my studio, I have an answering machine on my home phone—it's all bad business.

What kind of equipment do you have then, besides a drafting table?
I don't have a copier. My paintings are about six feet, but my illustrations are all about thirty inches in size, so I tend to work at a table, or I'll work on the wall standing up.

Title: *Frozen Images;*
Client: Visual Arts Press; Art Director: Marshall Arisman.

where they're afraid if they ask questions, they're going to look like they aren't business people. So they start acting like lawyers, asking "Where's my kill fee?" Where's my purchase order?" If I've done something for an art director and it doesn't go through, it's not the art director's fault, it's just something that happens. If the art director has no kill fee money, they'll make it up on another job.

Do you have a minimum fee that you will work for?
Not really.

Do you work mostly out of home or do you have a studio?
When I first got my studio, I thought that I would do my personal work there and all my illustration work at home. But then

How long have you been teaching at SVA?
Since 1964. In sixty-seven I became the head of the undergraduate Illustration Department. Ten years ago I started the graduate program in illustration.

How do you feel about art school education?
If I had kids, and they wanted to go to art school, I think I would try to talk them into going to a Liberal Arts school for two years. At art school we saw ourselves as artists who make pictures, and why were we reading all these books and taking all these classes that didn't immediately apply? That was a major mistake on my part. My mother, still, to this day, every single time I talk to her, says to me, "When are you going to get a full-time job?"

Many established illustrators feel they don't have a real job.
Well, it's a Catch 22, because on the one hand, you don't want people believing it's so much fun that you shouldn't be paid for it. On the other hand, it doesn't run like a job.

So with the graduate program, you learn your technical skills, and then you come out and find yourself?
It's funny, a lot of people we take in the graduate program are not as technically good as the undergrads are. But because they've been kicking around a little, they can move much faster.

All students think that an art director is going to give them a crit, like school. You know, some students will say to me, "I just want the feedback." And I say, "They won't have time for feedback." Art directors will tell you what you should do based on what they need. If you think that's an art conversation, you're going to make mistakes. You're going to keep thinking, "Wow, this makes critical sense, so I'll do some samples to please the art director."

Do you find if art directors only see black and white work, they think you can't do color?
Yes. I did nothing but black and white until 1975 because I couldn't paint. One job changed that. I did a thing for *Playboy* on Gary Gilmore, and it was in color. After that I started getting color work. There used to be a market for black and white work, not a bad one. Not now. Outside of newspapers it's gone.

Do you use the reference library to get your scrap?
I used to a lot, but after a certain amount of time you understand what kind of reference you need and build up enough of a library. Every four jobs I may have to go to a bookstore. I'll go to a bookstore first, because I'll think, "Well, maybe I'll need this again." But I use reference on every illustration job.

What is it about illustration that keeps you interested, if not passionate?
If you find yourself doing figurative work, it seems to me that this is a pretty clean operation. And the pay-offs are multiple. What I know is that I get to work on the total intuitive part of my body, and that's why people make those funny statements about getting paid for it. The secret is that I'm allowed to function with a non-rational, non-business head most of the time, and the rest of the world is willing to accept it as work.

Title: *Visual Scavenger*; Client: Graphis Press; Art Director: Walter Herdeg.

Title: *Nuclear Dawn*; Client: *Penthouse*; Art Director: Marshall Arisman; Designer: Frank Devino.

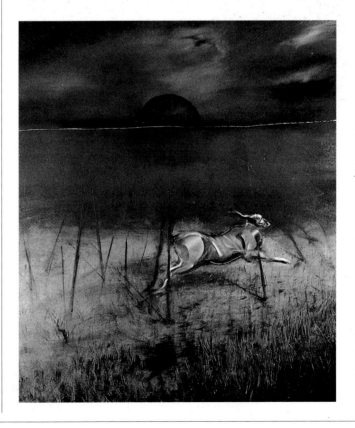

STEVEN GUARNACCIA

Steven Guarnaccia's work has appeared in books and magazines, on greeting cards for the Museum of Modern Art and on clothing for Swatch. His drawings appear regularly in *The New York Times*, *The New Yorker*, *Esquire* and *Abitare*, and his children's books include *Anansi*, *Blockheads* and *Naming the Animals*. He teaches a class called "The Satiric Image" at the School of Visual Arts.

How long have you been working as an illustrator?
I started illustrating in February 1977, so this February it'll be 18 years.

What kind of training or education do you have?
I attended Brown University and took classes at the Rhode Island School of Design. After two and a half years, I took a leave of absence to take classes in book arts, typesetting, and printing at the Scuola del Libro in Urbino, Italy. I worked for six months as a kind of apprentice for Bert Dodson, who worked mainly as a children's book illustrator, and then came back to continue working with him. I never returned to Brown.

(Above) Title: *Miss Blockhead*; Client: Steven Guarnaccia; Art Director: Steven Guarnaccia. (Right) Title: *Madball On Chair*; Client: Steven Guarnaccia; Art Director: Steven Guarnaccia.

Who were your mentors?
My first was my high school art teacher, Paul Toth. He introduced me to the work of George Grosz when he became fearful that I was in danger of turning into a cartoonist. Then Bert Dodson. I apprenticed with him, then collaborated with him, and then he gave me my wings. Paolo Guidotti, an Italian illustrator, introduced me to the desgin and illustration community of Milan. Bob Manley, the cre-

ative director of a small Boston ad agency, was the single most inspiring creative force for me—I did my best work with him. He had a tremendous amount of energy and a sense that anything was possible. Steve Heller has been the most continuous creative presence in my career, in his capacity as client—he commissioned my first illustration—and as collaborator—we just published our third book together, *Designing for Children*, this past year. And there have been seventeen years of projects and idea-sharing in between.

Who are your influences?
I discovered Saul Steinberg and my interest in Maurice Sendak's work was reignited at that time, too, though I'd grown up on his illustrations for the *Little Bears* books. Both Seymour Chwast and Milton Glaser made me realize what parameters of illustration could be. I mean, Glaser designed a cocktail for The Russian Tea Room! And Seymour Chwast's elegance

and goofiness influenced me a great deal. And Guy Billout for his conceptual approach and his purity of thought. I'm a big fan of illustration and I'm always in love with someone's work at any given moment. From the fine art world, Claes Oldenberg is a major influence. He made having a sense of humor in art

acceptable. I also love his use of scale.

How did you begin working as an illustrator?

When I felt I was ready to crack New York, Bert Dodson introduced me to Randall Enos, a very successful illustrator living in Westport. Randy, in an act of exceptional generosity, opened his address book of contacts to me. And John Alcorn later gave me Paolo Guidotti's name, along with those of other Milanese designers and illustrators. I had a makeshift portfolio of drawings from college and Italy and I took it to *The New York Times*. Michael Valenti and Richard Samperi asked me to illustrate Russell Baker's column on a monthly basis. The same day Steven Heller asked me to illustrate a letter on the "Letter to the Editors" page. I started to work for him on a regular basis. *New York* magazine also started giving me regular work at the same time. This was my school, my training on the job.

After two years of illustrating in New York, I felt I was perceived as a black and white "spot" illustrator. I started to become interested in decoration and color in addition to working in conceptual black and white. I went to Milan and with my black and white "spot" portfolio, got some high-profile large scale color commissions for Italian *Vogue*, *Abitare*, and Italian *Playboy*. In the states, if you don't have a cat in your portfolio, they think you can't draw a cat. I had a portfolio with no color work in it. I came back from Italy with color and was able to skip a couple of years of trying to get color work. Back in the U.S., Bob Manley, an art director at a small agency in Boston, saw a piece of mine in *The Boston Globe* and I worked with him for the next three years on an ad campaign for an HMO that included television commercials, brochures, newspaper ads, annual reports—wacky stuff, very creative.

Do you have a rep?

I don't have a rep in New York because I think my personal presence is an asset. Also, I didn't want to share my money when the majority of my work was low-end editorial. I was lucky enough to be at the tail-end of the era where art directors still personally saw people. But I do have reps in other places: CIA in London, Reactor in Toronto and Paris.

How is your business organized?

At the beginning, I worked and lived in the same space. When I got married I got a studio. My studio is really my playhouse.

Organizationally, I have an accountant who does my books. I have accounts with both an art supply store and an office supply store, and with photographic services as well. I keep a few hundred sheets of watercolor board in the studio, and I keep paints, brushes, and other supplies in stock. I have an account at Florent for

(Left) Title: *AL-U-Mini-um*; Client: Purgatory Pie Press; Art Director: Ester K. Smith. (Below) Title: *Free Agents*; Client: Harper & Row; Art Director: Joseph Montebello.

(Above) Title: *Giardino Museologico*; Client: *Abitare*; Art Director: Italo Lupi.

(Above) Title: *Blue Meanie*; Client: Steven Guarnaccia; Art Director: Steven Guarnaccia. (Right) Title: *Le Corbusier's Eyeglasses*; Client: *Abitare*; Art Director: Italo Lupi.

lunches. I also have accounts with Federal Express and UPS.

Do you have an assistant or have you ever hired an intern?
Yes, I have from 2–4 assistants at any given time. Two are full-time, who help with the phones, bills, sizing artwork, preparing watercolor paper and mixing paints. The assistants keep tight books and send them to the accountant monthly. I'm not good at this and want to spend my time on the creative stuff. Interns are great— their enthusiasm is contagious. They come for short periods of time and provide a boost of energy to the studio.

What kind of system do you have for keeping records of your work?
I keep my original art, sketches and tearsheets in files in my studio and I have about seventy-five percent of my work photographed in slide form.

For jobs, do you use reference material?
Very rarely. Only if something very specific needs to be in a drawing and I don't know what it looks like. I do have exten-

sive visual files in my studio, though, and sometimes I provide reference for other designers and illustrators.

Do you travel in your work?
I sometimes travel for work, whether on assignments or for exhibitions of my work or lectures. I regularly flew to an animation studio in Denver when I was designing some television spots for them, and to Boston regularly to work with Bob Manley. I've also had an ongoing working relationship with Italy.

How do you promote yourself?
My self-promotion program is very haphazard. Every Christmas or New Year I try to send something out. Sometimes it's a Christmas card I've designed for a client. One year it was Christmas cards I designed for The Museum of Modern Art. But I'm usually late, and I'm not that conscientious about updating my mailing list. Usually, I mail out to people I already work with, friends, not new prospects.

I don't buy any pages in promotional books like *Showcase*. I'm opposed to it because it's not the ideal context to look at illustration. I prefer to submit work to AIGA or American Illustration competitions—the fees are a fraction of what

(Below) Title: *Reinventing Government*; Client: *The New York Times Magazine*; Art Director: Janet Froelich.

you'd pay for a page in the promo books, and the company you keep is selected out. I try to keep doing work for high-profile clients who tend to not look in the *Black Book* or *Showcase*.

Do you sell your original art?
I used to sell my work through the Illustration Gallery, but selling my work has never been a major source of income. I like the idea of people owning my work. My general philosophy is, I've already made money on this so I'm willing to part with it at a modest price.

Do you have a minimum fee that you won't go below on an assignment?
That's a tough question. My fees vary depending on the job. They start at $500 for a spot. I ask $2,000 for a book jacket if I'm designing it as well. On the other hand, I'll do a book jacket for $500 if it's a project I really want to do. I keep a note on my bulletin board reminding me not to say "yes" to a fee impulsively. Often I'll ask the client if I can get back to them and then look at my schedule, the parameters of the job and how badly I want to do it before I call back with an answer.

What are you thoughts on teaching illustration?
I've been teaching illustration for twelve years, ten years at Parsons School of Design and two years at the School of Visual Arts. In there, somewhere, I taught a year at the Rhode Island School of Design. I feel the best I can do is bring out of a student what is already there. I don't know enough about the technical side of illustration to teach drawing or a technique class. My education really began when I left school. I don't think, in any case, that school should be seen as a direct route to a career in illustration.

How much of your work is editorial versus advertising or corporate?
One to two years ago, editorial was maybe 25% of my work, advertising was 5–10% and the rest was split between corporate and publishing. Editorial deadlines were too short and budgets were too low for me to take on more than that amount. Now, half of my work is editorial. Corporate work has dropped off. The other half includes designing neckties and jewelry and illustrating books. I initiate a lot of my own projects and the creative satisfaction is great, even if the ties don't sell very well.

Do you have any advice to art directors and designers on how to conduct business with illustrators better?
I feel lucky to be able to work with some of the more creatively challenging people in the field. I don't like to be given a pre-digested idea, where I'm just used as a pair of hands. But that doesn't happen very often.

What is the most fulfilling aspect of your work?
Being invited to exercise my creativity as fully as possible and being paid for it.

What would you say is the most difficult part of your work?
The ever-present danger that this wonderful way to earn a living could become just a job.

(Left) Title: *Neckties*; Client: Esquire Neckware; Art Director: Carrie Seligman.
(Above) Title: *Schwing* and *Lawdy* pins; Client: Acme Studios; Art Director: Adrianne Olabvenaga.

ANITA KUNZ

Anita Kunz graduated lives and works out of Toronto on a freelance basis for magazines, book publishers and advertising agencies. Her clients include *Rolling Stone*, *The New York Times*, *Time* and *Newsweek*. Her paintings have also appeared in group shows internationally. She divides her time between Toronto and New York City.

How long have you been working as an illustrator?
I've been in the business for 15 years.

What kind of education did you have?
I graduated as an associate of the Ontario College of Art in Toronto, Canada. It was a four-year program. Also, I attended the Illustrator's Workshop in Tarrytown, New York.

Who did you study with? Did you have any mentors?
My mentors were Doug Johnson who taught me at school, and Marshall Aris-man, who encouraged me afterward. Also, as I was growing up I had an uncle who was an illustrator for children's educational publishing, such as film strips and high school text books, so doing art for print has always been familiar to me.

Who are your influences?
Figurative Renaissance painters, Flemish Primitives, British illustrators, like Sue Coe.

How did you begin working as an illustrator?
My career began before I finished my

(Left) Title: *The Four Wise Men*; Client: Aventura Books/Random House; Art Director: Keith Sheridan. (Right) Title: *Jim And Tammy Faye/Adam and Eve*; Client: *Regardie's* magazine; Art Director: Fred Woodward.

MICHEL TOURNIER
THE FOUR WISE MEN

By "the most exciting novelist now writing in French" (The New York Review of Books), "a work of extraordinary clarity."—New York Times Book Review

fourth year in school. I started showing my portfolio around to art directors. Things did not happen quickly for me. But I lived cheaply, so the pressure wasn't so great. Then I started looking at British illustrators' work because of Robert Priest and Derek Ungless, two British art directors working at *Weekend Magazine* in Toronto. I was impressed by illustrators like Ian Pollock, Russell Mills, Sue Coe, Robert Mason, and Ralph Steadman. I went to London for six months. There wasn't much work available, but the people were great. Back in Toronto, I started looking at American work. I called Marshall Arisman, showed him my book, and he was very supportive. He gave me names of art directors to call. I met Steve Heller at *The New York Times*, who was also very helpful in launching my career, especially when he wrote an article about me in *Graphis* magazine. My career moved slow and steady.

Let's talk about business. Do you think illustrators should have a rep, and do you have one?
I don't think one needs a rep for editorial work. Reps don't want editorial—they want big bucks. However, I have had loose arrangements with a few reps like Sharpshooter in Toronto, Sharp Practice in London, one in L.A., and another in Japan. But the work I get from them is occasional and not that profitable. Frankly, I don't want to lose control of my career, although I like the idea of having a rep and getting work I wouldn't get for myself. I don't want to be talked into doing jobs that don't interest me. I also feel that my work is not commercial enough for reps to want to represent me.

I have been told repeatedly that my work is too editorial. Reps would probably be very valuable for acquiring corporate work, especially in negotiating fees. Nevertheless, I'm going to try another rep to broaden my client base.

How is your business arranged?
I split my time between Toronto and New York, with studios in both cities. I have been incorporated for a long time. Compared to photographers, illustrators don't need much to operate. My main studio is located in the back of my house in Toron-

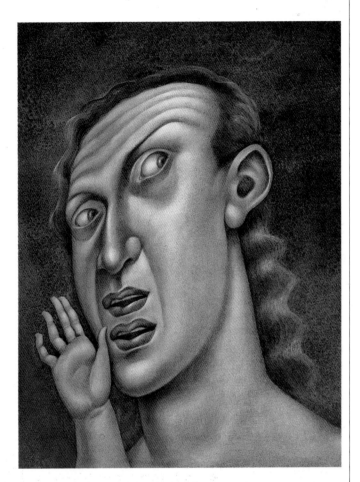

to. I have a table, a taboret, a tabletop copier and a fax. I also have shelves filled with books. I keep a large supply of Crescent board #110 in my studio—it's getting harder and harder to find. I keep my published and original work in flat files. I have an accountant and a bookkeeper, but I do my own invoicing. I have an account with Federal Express and I also have an account with a local cab company that delivers jobs for me. Being a freelance illustrator is somewhat isolating and therefore I spend a lot of time on the phone. My phone bill is very high.

Title: *Liar #1*; Client: *The Washington Magazine*; Art Director: Michael Walsh.

Do you have an assistant?
I have no assistant, have never hired one and wouldn't know what to do with an intern.

What kind of system do you have for keeping records of your work?
I have my work photographed every now and again as thirty-five mm. slides or 4×5 transparencies.

Do you have a lawyer?
I've never hired a lawyer, but I once did an illustration of Betty Boop for *Playboy* magazine and the publication was sued for the character's usage in the context of the magazine.

How do you promote yourself?
When I first started out, I entered *Graphis* annual competitions shamelessly because they were free. This served as a promotional vehicle. I also used to do mailings of slides and tearsheets of my work to art

(Right) Title: *Scanners*; Client: Grenville Press; Art Director: Carmen Dunjko. (Below) Title: *The 1987 Canadian Opera Company Annual Poster*; Client: The Canadian Opera Company; Art Directors: Scott Taylor and Paul Browning.

directors. Now I try to send out a Christmas card every year. I've always been aware of the importance of having my work appear in annuals and the exposure that it brings. I have paid to appear in *Alternative Pick* and *The Society of Illustrators* book, but I really believe in the side benefits of appearing in high profile magazines such as *Time* and *Rolling Stone*. After my images appear in these magazines, I inevitably get calls for other work that same week.

Do you sell your original art?
Although I have had a few exhibitions of my work, I don't sell a lot of original pieces. I have sold a few to corporations through art galleries, but it is not a money-making venture. I enjoy participating in shows such as those at the Illustration Gallery, but I am not dependant on it at all. My work is not done to be hung on walls and I worry about the permanency of the actual paintings.

Do you have a minimum fee for an assignment?

No, I don't have a minimum fee. It depends on who is commissioning the work. It should be worthwhile.

Have you ever taught illustration?
I taught illustration at The Ontario College of Art in Toronto for one year. Now I teach at workshops. I enjoy teaching but find it difficult, especially in trying to be objective. Because my work is so personal, I try to help the students find their own voice. I firmly believe that if people are going to make it, it will be through drive and hard work, not education. It helps, but it's no guarantee. The amount of sweat you put into it is totally related to the amount of success.

Have you experienced any discrimination being a female illustrator in a dominantly male field?
Is it dominantly male? I don't know. Ideally, this business has no limitations. It comes down to the quality of the work. However you arrive at that is up to you. There's no hierarchy. I find that sometimes I am hired because the content is of interest to women and my point of view is requested. Sometimes I feel I am asked to speak at a seminar because of the female quota. But I don't think there are any differences between male and female illustrators. I'm not sure there are more males than females in the business. I think there are more female art directors.

How much of your work is editorial versus advertising or corporate?
90% of my work is editorial, 9¾% is books and only ¼% is advertising. I do not do corporate work, which suits me fine, although I would like to get more work in the entertainment industry doing CDs, theatre set designs, movie posters, etc..

Do you have international clients?
My clients are mostly in North America, with some in England, Germany and Japan. I've always had a variety—serious and light, a combination of portraits and conceptual illustrations. I try to steer it if I'm getting too much of a certain assignment repeatedly in a given time by just mentioning it to art directors. Also, I try to control the types of projects that I get and most art directors are sympathetic.

What is the most fulfilling aspect of your work?
I've always liked being a part of the media—commenting on world events. You learn a lot.

Title: *Liar #2*; Client: *The Washington Post Magazine*; Art Director: Michael Walsh.

What is the most difficult part of your work?
The business side...the isolation...the mental blocks...deadlines...and challenging myself—but I feel lucky that I can do this for a living. I've never had a real job.

HENRIK DRESCHER

Henrik Drescher was born in Denmark in 1955. He attended The Museum School in Boston for one semester and dropped out. While travelling around the U.S. and Mexico he kept "notebooks," which later became his portfolio for illustrations. He has published at least 15 children's books and he illustrates for all the major publications. He lives in Berkeley, California.

What is your art education and training?
Other than that one semester at The Museum School in Boston, I'm self-taught.

Did you always know that you wanted to be an illustrator?
I started knowing when I was fifteen. I began drawing when I was fourteen. At that point I was copying the style of a friend of the family who was a cartoonist in Denmark. Then I started looking at Alan Cober and Milton Glaser. When I went to high school I learned by looking.

Who influenced you most?
Max Ernst, art of the insane, *Mad* magazine, old Sears catalogs, Edward Gorey, Joseph Beuys, random doodles, Hare Krishna pictures, John Heartfield, Joseph Cornell, George Grosz, Frida Kahlo, Charles Adams, Wolfgang Laib, William Blake, fetish drawings, Cy Twombly, tattoos, sticks, rusty tin cans, moghul miniatures, tantric paintings, Alan Cober, Brad Holland, Ralph Steadman, postage stamps, anatomical diagrams, children's drawing, Peter Beard and Jim Dine.

What was your first job and how did you get it?
It was in 1974, I think, and my first job was for Ronn Campisi. He was art direct-

ing at *The Real Paper*. It was a low-budget radical tabloid. I just showed originals and my notebooks.

How do you view the business of illustration?
It's the nature of people to work differently. For me, I'm not even organized enough to think about it. I'm casual about my work. The only thing you have to be able to do is put out and deliver on time. You don't even have to put shoes on.

Now that everyone uses faxes and Fed-Ex, there seems to be more distance between illustrators and art directors. Does this make the business even more casual and less business-like?

(Above) Title: *Pat the Beastie*; Client: Hyperion Books for Children; Art Director: Patrick J.P. Flynn. (Right) Title: "Education Infiltration"; Client: *The Progressive*; Art Director: Patrick J.P. Flynn.

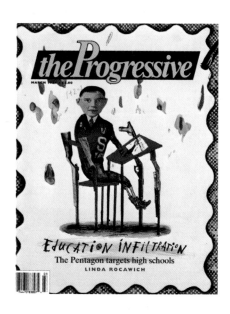

I started working before Fed-Ex. Back then you had to drop stuff off and you had to see the art director. It was an opening of sorts, and you were more nervous. When you haven't met the art director, and you've only talked on the phone, you can be really spontaneous. Fed-Ex really freed me up and, of course, I could live anywhere. When faxes came around, that was it for me. Now with modems, it's going to get even better.

What's the down-side of all this high-technology?
Well, I think it's the reason art directors don't see artists in person. Even when there was Fed-Ex, you still had a rapport with the art directors. Now they take it for granted. It's the virtual world. It's sad. But for me, it opened the stage to be really wild. So if there were phone calls complaining about what I did, I would just get a message on the answering machine.

You've had Reactor Art & Design as your reps for a long time. Are they the only reps you've ever had?
I had a brief interlude with somebody else, but they didn't get me any work for a year. Frankly, I think that I have gotten the rep more work than the rep has gotten me. Reactor is especially good because they serve almost as a secretary. If I go away, Reactor takes all my calls and reaches me when necessary. People have this fear of doing business long-distance, so Reactor doesn't tell people where I am. Even though I've been with them for about ten years, Reactor doesn't have exclusivity on me.

How is your business set up, in terms of location, equipment, etc.?
I used to have a studio, but now I have three kids and I work at home. I have a fax and a copier. The thing is you don't need anything. You don't need a fax, either, let's face it. The whole fax thing is a way to work closer to the deadline. Before faxes

came along, it was great because you could just explain something over the phone. Or if they really needed it, you could Fed-Ex the sketch.

How much of your work is editorial?
Kids' books is about half of what I do. And the rest is editorial. That's not counting my own work. I do quite a bit of painting in my notebooks.

Do you do any corporate work or advertising?
Very little. They haven't come around to me yet.

What about international work?
Very little. I've just gotten a job from Switzerland, and I've worked for other European publications. That's a place where a rep would probably come in handy. In a lot of ways, I can't imagine having more work. I would like to have higher-paying work, but I can't imagine working harder.

(Above) Title: *Setting the Muses Free*; Client: Peat Marwick; Art Director: Donna Bonavita. (Below) Title: *Sardine Can*; Client: *Entertainment Weekly*; Art Director: Joe Kimberling.

Do childrens' books pay well?

No, they don't. They advance anywhere from $15,000 to 25,000 but you have to earn it back to get 10% and the chances of that happening are usually pretty slim.

You have sent out special booklets and postcards over the years. Is that your primary form of promotion?

I don't do much promotion now. I used to do little books, but my interest was more in communicating with people, trying to

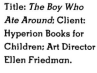

Title: *The Boy Who Ate Around*; Client: Hyperion Books for Children; Art Director Ellen Friedman.

you get going and they latch on it can be heaven. She did my bookkeeping, straightened up my studio, plus she colored and cut up artwork. I don't think I have the patience to do that again. You know, what I do is so personal that I can't really farm anything out.

Do you sell your original art?

Yes. Both my magazine work and my paintings. I'm really interested in fine art, per se. Not in a snobbish way, but I'm inter-

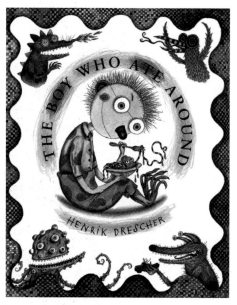

ested in making pictures that I can stand looking at for more than thirty seconds.

In your transactions with art directors, have you ever had your work lost or damaged?

I've had it stolen in the sense that an art director has asked to buy it but can't afford to pay more than fifty bucks, and then never pay, so what can I do? It's sort of like bribery.

Do you find that as you become more established you can demand higher fees?

What happens when you become more established is that people don't call you anymore. People get scared away. And also they get burned out on you. But I've always been pretty audacious about just asking for more money.

do stuff that was fun or different. But I think that kind of stuff gets lost now. I don't think people really look at it.

Have you ever had an assistant or intern?

I've had an assistant in New York City. It's hard work getting somebody going. Once

Would you turn down a $500 cover for a small magazine?
No, not at all. I don't turn down that much work, you know. I'm the father of three and I've got a lot to pay for. Unless it's totally repugnant, and in that sense, I'm an illustrator. I can figure out how to do it. I regret doing it, but I can figure out how to make that piece work into what I'm interested in.

Because your work is so personal, are you more limited as to what kinds of jobs you can do?
No. Actually, I'm pretty versatile. I do these kids' books, I do stuff for *Money* magazine, *Time* and *Raygun*. I really do stuff way across the boundaries.

How do you feel about the teaching of illustration today?
It's kind of pathetic the way kids are recruited to all the schools. I think there's going to be this huge backlash because the business is just flooded. Whenever I go to talk at schools, I just think that it's their responsibility to teach these kids something besides illustration. Whether it's graphic design or something interesting that can earn them a living. Art schools should really be about more than just technique and composition. It should be about culture and philosophy.

Do you have any thoughts on the process of dealing with art directors?
I think art directors should see people, but it's impossible when you get five hundred mailers a week. I understand why they don't.

Does it bother you if art directors don't call you back after getting a piece of art?
No, it doesn't bother me. You know what I suggest? Rather than doing that is sending a fax or a letter. I think there's something cumbersome about having those conversations. You know, I've always been shy about dropping stuff off and I'm always

Title: *Literary Cavalcade*; Client: Scholastic Publishing.

sort of shy about listening to compliments. It's almost as if I like negative criticism better because then I can fight back. But usually I get called. It's a gauge of either how busy the art director is or how interested they are. Definitely I've worked for people who are just not interested and you can tell. And that's kind of a bummer. It's really nice, especially if you work for newer, younger art directors, when you get a call from them and they're excited about what's happening.

What is it about this business that you enjoy?
It would be totally frustrating to have all this stuff to say and not have a forum to do it in, for one thing. Fine art alone would probably not do it for me. My pictures have changed a lot and I'm still developing, but I work it out in the printed page. It's been valuable for that.

Title: *Bringing the Message Home*; Client: Peat Marwick; Art Director: Donna Bonavita.

AMY GUIP

my Guip was born in Cleveland in 1965 and graduated from Syracuse University in 1987. She specializes in photocollage. Her clients include Nike, Frankfurt, Gipps, & Balkind, Drentell Doyle Partners, Warner Records, Polygram, Sony Music, EMI, Elektra, Atlantic Records, Geffen Records, *Rolling Stone*, *Entertainment Weekly*, *Raygun*, *Newsweek*, *Time*, *The New York Times*, *Esquire*, and *Spin*.

How long have you been in the business?
I just turned 29, and I graduated when I was 22. So, seven years.

Were you doing your own work prior to graduating from college?
My father managed illustrators and my mom was a ceramics teacher. I grew up in my dad's office. I've been entering art contests since I was in kindergarten.

Did you know at a young age that you wanted to do illustration?
No, I wanted to do advertising. I wanted to make money.

Did you have any mentors?
I grew up with *Communication Arts* annuals on my coffee table. In the summers I would get the *C.A.*s, and Matt Mahurin was my first big influence. I grew up just kind of flipping through that stuff. But as far as mentors go, just my father.

So, your father was a big help to you?
He would say things like, "Here's this graphic designer, Milton Glaser. I think you ought to call him up and talk to him." He ran a graphic arts stu-

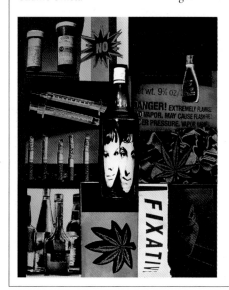

Title: *Kids And Drugs*; Client: *Healthy Kids* magazine; Art Director: Charlie Ornett.

dio out of his house, so I learned a lot through that. When I left college, I went to work at the *American Illustration* offices. There were just two of us in the office so I got to see how the annual worked. I collected all the names of art directors and got a mailing list that way, which was an incredible start for me.

You mentioned Matt Mahurin as an early influence. Who or what else?
The Surrealists and the Dadaists, Man Ray, Magritte and Duchamp. I love a lot of old Roman and Greek painters. The religious paintings definitely have influenced me. And now the Starn twins, of course, have just completely influenced me. I love the photographers like Penn and Avedon, and current photographers like the Douglas Brothers.

After school you got a job. So how did you launch your illustration career?
American Illustration was pretty much full-time, like 30 hours a week, and it was flexible enough where I could drop my book off. I did a mailer right away using four images which I thought said what my work was about. I made a small portfolio of 21/4 transparencies. I sent them out to about 12 different people. I had three different cards and would rotate them, including a self-addressed, stamped envelope that they would send back. I ended up getting work from almost every one of those people. The cards are the

thing. I did a second mailing of more individual cards, a hand-printed photograph with caligraphy on the back. To this day, I still see them on some people's walls. After that, I would send out maybe five different tearsheets and one printed photographic image. A year or so after that, I quit *American Illustration* and worked solely on my illustration.

You got your start in the music industry. How did you manage to break in there?
I had a school friend, Joanie Schwartz, who gave me her mailing list. She told me to see an art director who really loved my work and gave me a project right away. And it snowballed. Someone sees one thing and that's it. I did another project for RCA. And that led to my third album cover, a Kiss cover. So someone sees your work, they like it, they show it off. Someone else see it, and I'm marked as a heavy metal illustrator. There was a market out there for it. I look back at that and I really hate all of it, but it got me into that music area. And then the medical industry, I got a lot of work from magazines like *Post-Graduate Medicine* and *Medical Economics*, *Psychology Today*, *Health* and *Hippocrates*. Those were the areas where I blossomed in the beginning. *Regardie's* was a big starter for me too. John Korpics gave me a column to do every month. I luckily had the chance to do a column for *Spin* after that. But those were really good magazines for exposure. That's how I got started. It was pretty easy, but I've seen a lot of people I've gone to school with not get one job. I don't know what it is about their work that wasn't happening, and mine was. I think I hopped on a trend at the time. I was very influenced by a lot of people, so, my work wasn't as original in the beginning. I'd say that my style and my personality has come through. It was really

dark illustration. Art directors and editors wanted my kind of illustration to illustrate date rape and all those social issues.

Do you think that having a rep is useful?
I don't need a rep to get more work. I want to have a rep to move me into different areas, like advertising, and to handle my music packaging a little better, because I can make a lot more money in merchandising.

What percentage of your work is editorial?
I'd say it's about 70% editorial, 25% music, and 5% design firms.

How is your business organized?
I live and work in the same space. I have a full-time assistant who does all my billing.

Title: *Safe Sound—How To Listen to Loud Music And Still Protect Your Ears*; Client: *Request magazine*; Art Director: Scott Anderson.

(Above) Title: *The Worst Place To Die*; Client: *New York* magazine; Art Director: Robert Best. (Below) Title: *The Silent Majority*—cd/cassette cover artwork for Life, Sex & Death; Client: Warner Bros. Records; Art Director: Deborah Norcross.

I have a logo, but I don't have my formal letterhead and invoice done up properly. We're still invoicing by hand. My assistant does a lot of my business work for me. I have an accountant do my taxes, but my assistant keeps books for me, and she's incredible at it.

My bookkeeping is a little more difficult because I incur expenses with jobs. With some of my record packages, my expenses can be upwards of $10,000. I couldn't do that myself and be able to work. I just don't have the time.

What other equipment do you have?
My dark room is gorgeous. That's where my expenses go. I just bought another enlarger. My ventilation system alone is worth $2000. I bought a computer for my husband, which was a big expense. I use it for accounting right now. We have everything set up for Photoshop. Because I need to shoot here, you know, I can deduct a lot more, which is quite helpful.

Do you have your original art photographed?
I should because my artwork changes in color over time, and in gluing, but I don't. It gets kind of pricey.

Are you satisfied with the fees paid to illustrators for their work?
I make a good living. If you are asking if I'm compensated for the time it takes me to do a job, it probably takes me a hell of a lot longer, just because there's more to produce. I make ok money, but for the amount of time I have to put into it, it really doesn't end up to be so good.

Have you ever had to hire a lawyer to intercede in some client/artist problem?
I did a piece for RCA Records that was not used because they never produced the album. They wanted to use it for another album cover and they said, "Send us the transparency." I said no, because they were using it for a totally different project and they would have to pay me again. They refused. I said to them, "If you have a problem with that, just call my lawyer." And so they called him, and he said, "You're not getting it until you pay her all over again." I waited until the check was in my hands to give them the transparencies.

Do you use reference material?
Tons for ideas and for my actual imagery. Ideas, I get in the library. I just love going through stuff. It jogs my mind.

Does it help when you appear in high-profile magazines? Do you get calls that week or the next week?
I used to ask where they'd seen my work. And people would go, "God, everywhere." I think a lot of people see the stuff in *Entertainment Weekly*. And I did a piece for *Time* magazine over Christmas that, I must say, my entire hometown saw. That's why you have to do that work. Plus, I like doing it. But I don't know who sees what.

You've had a lot of work appear in

American Illustration. **Has that helped you get work?**

It helped me break into doing more three-dimensional collage things. That book's incredible for work. Art directors say, "I want that stuff, like, in *American Illustration*." I don't submit to any other annuals.

Do you think students should study illustration in school?

I think people don't teach the business end of illustration enough. These kids get out of school and they don't know where to begin. So much of it is marketing at first. Your work can be great, but if no one sees it, it's not going to sell. I don't think teachers emphasize concepts enough, either. You've got to develop your own way

of saying something. Most students just want to create a cool image and forget that they are supposed to be summing up what the article is about.

Do you find being a freelancer too isolating?

I did for a long time until I had full-time assistants. They're my friends now. But I have no idea what any of my editorial clients look like. I never meet anyone. With the music industry, it's a little more personal. I'll go into their offices to meet with them. And that's the only time I have

any kind of interaction with an art director. I don't know any illustrators. I know more photographers just because that's what my friends do, but they don't do editorial work. I'm kind of thirsty for what's happening out there, and talking about it, and finding out how other people work, and that kind of thing. It's very isolating in that way. But it's more isolating, because I work all the time. I go to bed with it on my mind. I find that really aggravating. And so I'm trying to work on it. It's hard in one sense that now that I have an assistant, I don't get to go run my errands as much, and get to go to the book stores, or get to go in the art stores, or get to go pick out fabric and see what's out there, because everytime I go into a hardware store, I get ideas. That's isolating, but it was much worse before.

What is it that you enjoy about this business?

Getting paid for doing your own work. I really like having to solve a problem. I like being caught up in the media too, and working on now subjects and on politically-related things, and being able to influence people in that way. I know so many people who hate their work, so it's just great to want to get up in the morning and do your work.

What is it that is the least fulfilling?

The same thing. Not being able to get away from it. Not being able to sleep well. I'm always worrying.

(Below) Title: *Straight Up Sewaside*—cd/cassette cover artwork for *DAS EFX*; Client: East West Records; Art Director: Larry Freemantle

(Above) Title: *The Myths of Motherhood*; Client: Houghton-Mifflin; Art Director: Michaela Sullivan.
(Left) Title: *Recording in Soviet Dis-Union*; Client: Raygun; Art Director: David Carson

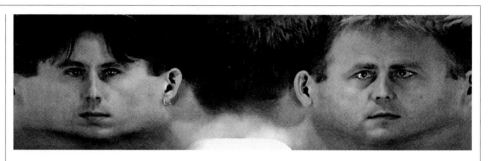

OKO & MANO
Mirko Ilic and Alex Arce

irko Ilic is an illustrator and art director. Born in 1956 in Yugoslavia, he arrived in the United States in 1968 with a portfolio of work published in Yugoslav and European magazines and newspapers. He has been art director for *The New York Times* Op-Ed page and *Time International* magazine. In 1994, Ilic joined Alejandro Arce in a partnership called Oko & Mano in New York City. Alex Arce was born in 1965 and has an extensive background in computer electronics, design, illustration and animation. Together they create computer-generated illustrations for various clients ranging from magazines and newspapers to annual reports and television networks.

(Above) Title: *Shock Therapy And Its Victims*; Client: *The New York Times*; Illustrator: *Mirko Illic*; Art Director: Michael Valenti.
(Right) Title: *Drip, Drip, Drip*; Client: *The New Republic*; Illustrator: *Oko & Mano*; Art Director: Eric Baker.

What does OKO & MANO stand for?
M: Oko is "eye"in Slav (my heritage) and Mano is "hand" in Spanish (Alex's Mexican heritage) and the '&' is American, combining us together.

How many years have you been in the business?
M: As Oko & Mano, under a year. I published my first illustration when I was seventeen, now I'm thirty-eight, so I've been in the business for 21 years.
A: As an illustrator, a couple of years. Before this I did a lot of business graphics and then went straight into animation.

What kind of education and training have you had?
M: I completed a program in a school of Applied Arts in Zagreb. I was there for five years.

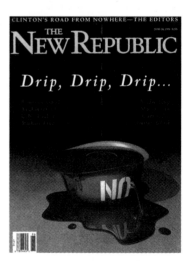

What did you do after that?
M: I started to work immediately. In school I was already publishing illustrations, designing posters and doing animation and design. I just continued to work afterward. I also did a lot of comics.

Did you have any mentors?

M: I decided to be an illustrator when I saw a piece illustrated by Brad Holland about a junkie in *Graphis*.

Were there any fine artists that influenced your work?

M: I was never into fine art. I looked to people like Milton Glaser and Seymour Chwast—renaissance-type illustrators.

You were already working when you were in school, so after you graduated, what did you do?

M: My last year I hardly showed up at school. I was working in Zagreb at animation. My teachers knew that I was there and that I needed money, so nobody said anything. After that I started to publish more illustrations. I became the editor for illustration and cartoons at a youth paper which was extremely successful. I also designed record covers, posters and everything else.

When did you come to New York?

M: 1986 and the first week I got to do a cover for *Time* magazine. I did roughs. They didn't like them. I didn't know at that time they were going to three different people for roughs. I was in competition with Seymour Chwast. He got the cover.

Alex, how many years have you been in the business?

A: When you say the business of illustration, I would have to say about a year.

What sort of training or education did you have?

A: I started in electrical engineering but didn't like it so I switched to fashion design, which I did like quite a bit. Then I started working while I was in school, doing everything from typing letters to doing charts and graphs, and that's how I got experience on the computer.

Where did you go from there?

A: I got my first job at a small electronic publishing company. This was in 1987 when desktop publishing was just becoming a big thing. I was a supervisor but they didn't really have any staff; everybody was freelance. They grew a lot and that gave me the experience to get a job at *Time*.

What was your position at *Time*?

A: I was hired to computerize the art department. No one really believed in the computer at that time. The way we really

Title: *The Frequent Flier Fallacy*; Client: *Worth* magazine; Illustrator: *Oko & Mano*; Art Director: Ina Saltz.

made it a sale was by doing covers. When I got the very first color printer, I started doing cover comps and showed one to Rudy Hogland. He complained about how the logo was the wrong size and the type was the wrong typeface and the red border was two points too large. So I said, "Okay, I guess you don't like it." I fixed it and brought it back to him in half an hour. Within a couple weeks we were doing all the cover comps that way. Eventually, when my project was finished, it was the whole magazine. But even then, on the side, I had started my own company to do animation on the Mac.

Who were your clients?

A: A lot of industrials, point of purchase stuff, a really specific market. A few training and educational tapes. That was way

before people started using the computer for real animation. It was just fun.

M: That's how we became friends.

How did you start Oko & Mano?

M: I bought my first computer before I got the job at *Time*. Alex knew a lot about computers I asked him for advice. He helped me buy everything, brought it to

(Left) Title: *Double Whammy*; Client: *The Wall Street Journal*; Illustrator: *Mirko Ilic*; Art Director: Joe Dizney.(Right) Title: *Free Your Mind*; Client: MTV; Illustrator: *Oko & Mano*; Art Directors: Jeffrey Keyton, Stacy Drummond, and Stephen Byram.

my house, hooked it up and then I was calling him every five minutes. I was thinking, "Should I throw the computer out the window or should I call Alex?"

A: He had the worst experience with a computer of anybody I've ever met.

M: My first Photoshop job was a cover for *Time*. My first illustration job in Illustrator on the computer was for *The New York Times*. There is no time for experimentation when you need to make money.

What was your first joint project?

M: A poster for The Golden Globe Awards. We didn't know how complicated it was.

A: It was a three-day job that dragged over two months. We were sitting there with this $70,000 computer, no manuals and I didn't have any training. I was just wandering around clicking on everything.

Do you have a rep?

M: No. We don't even have business cards.

Are you ruling them out altogether?

M: No, but having a rep is really like a

marriage. You must find somebody who appreciates your work, who's going to protect you and not think that you're only one of twenty-five artists in their stable.

Mirko, did you have a rep as a sole illustrator?

M: In the beginning I had two reps. Since English is a second language, I needed

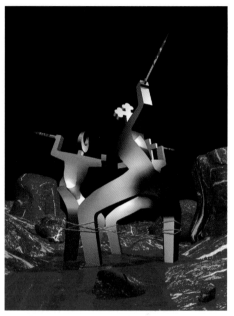

somebody to help me communicate. Then I discovered it was more of a burden to deal with my own rep than with clients. At one point I had a real hunger to do posters, because that's what I was doing in Yugoslavia. The rep didn't bother because there's no money in that. My promotional pieces were mostly whatever they wanted, and I didn't like it.

If you could find the right person, would you get a rep?

M: Yes. There's going to be more reps for the electronic part of the job. If you do a big animation job there's more money. That's the future. *Showcase* is now publishing a CD ROM directory.

What percentage of Oko & Mano work is editorial, corporate and advertising?

M: Most of it is editorial for two reasons.

First, people don't know we exist yet. Second, because I'm getting calls for Mirko Illic. But little by little word is spreading that we are shifting emphasis to the computer.

What about advertising?
A: I worked on a commercial, television stuff—that's really the direction we're going in.

Do you have any assistants?
M: We have the dog.

You have your Silicon Graphics System. How expensive is it?
A: This model, the Indigo II, is worth about $115,000. We use a software program called Soft Image. It was designed by animators, the same software used in the movie Jurassic Park.
M: I have part of a computer system at home because I do jobs on Illustrator there.

When you bill clients, do you add things like faxes, phone bills and deliveries?
M: That would waste more of my energy than I really want.
A: Whenever I do consulting work, I try to do it at a flat rate. It's too hard to keep track of all the little details.

Your original art is electronic. How do you keep records of your work?
A: We have transparencies and digital back archiving.

Are you satisfied with the illustration fees? Do you think you're being paid well for your work?
M: We're getting the same fees as any other illustrator because our names are known. However, for the price of one illustration you get two illustrators.

What kind of reference do you use, the picture collection at the library, or stock photohouses?

M: Books mostly. I have a very good memory. I remember images.

What about photographic backgrounds in your computer work? That is reference, isn't it?
M: They're on CD-ROMs. Lots of companies provide them.

Do you have any advice to art directors and designers on how to conduct business with illustrators better?
M: Our main problem is deadlines. We will get a deadline, we will break our necks, and then you discover there is another two days. What happens is you won't trust their deadlines anymore, and then when it's a real deadline, it's a total panic.

As an editorial illustrator are you usually asked to illustrate someone else's idea?
M: That's where the problem starts. I cannot draw for a pro-abortion article and then, against-abortion article, and sign my name to both. The editor should let me have the opposite point of view from the article.

What is the most fulfilling thing about being illustrators?
A: For me, it's the freedom. This job allows you to live without having a job.
M: I think I am making a difference with editorial illustration. I come from Bosnia. I know how important it is to make a statement and raise awareness.

(Top) Title: *Finding The Most Promising Stocks*; Client: J. P. Morgan; Illustrator: *Oko & Mano*; Art Director: Kevork Babian. (Bottom) Title: *Germany Toward Unity*; Client: *Time magazine*; Illustrator: *Mirko Ilic*; Art Director: Rudolf Hoglund.

GARY KELLEY

Gary Kelley has a degree in art from the University of Northern Iowa with an emphasis in drawing, painting and design. He began his career as a graphic designer and art director before turning to illustration. Kelley has received numerous awards, among them 17 gold and silver medals from the Society of Illustrators. Kelley is a frequent lecturer at the Smithsonian Institute, the Society of Illustrators and many colleges and universities around the country.

How did you start out in this business?
I'm self-taught. Although I did study drawing and painting at school, I never learned how to do art for reproduction until I started working as a graphic designer. I was a partner at a design firm. After some time, I decided that I didn't want to design as much so I switched to illustrating.

How did things change for you?
At the design firm I had to concern myself with the creative happiness of others, as well as all their business needs. When I left, I started worrying about myself. It took up more time. Sometimes I get totally frustrated because I spend so much time on the business side of things.

Who were some of your influences?
When I was growing up as a child in the midwest, Frederick Remington was one of my favorite artists. So was Charles Russell, and of course, Norman Rockwell. When I was learning to be an illustrator, I admired Mark English, Bernie Fuchs and Fred Otnes. I'm always looking for new influences. They change daily.

How would you say influences are best used, not abused?
I try to tell young illustrators not to feel that you have to stay true to one influence all your life. Look for new influences and see how you can use them in your own

(Above) Title: *Night Calls*; Client: Capitol Records; Art Director: Tommy Steele. (Right) Title: *Mystery Woman*; Client: *The North American Review*; Art Director: Gary Kelley.

work. Later you start to bring your own style to it. Nothing is original.

Do you feel that illustration fees are fair?
Some magazines haven't changed their fees in decades. I guess that's related to the fact that illustrators aren't as important as they used to be in editorial. Photography and computers have become more important. Advertising pays the most and offers the least flexibility; editorial pays the least and offers the most flexibility. Usually, you have to start at the bottom and work your way up.

How is your studio arranged? Do you work at home or in a separate studio?
I work in a separate studio, although I did

have space at home. I leased a copy machine and bought flat files. The studio space is very reasonable here.

What percentage of your work is advertising, editorial, corporate and books?
I'd say maybe 25% is advertising, books are another 20%, editorial is maybe 35% and the rest is miscellaneous, such as posters and annual reports. I've learned I can't make a living just doing books.

How do you work with clients?
I think I'm fairly realistic about each job. Most art directors let me have a say about a piece. They know I won't be a risk.

What about doing corrections?
If an editor or client start making too many big changes, it's usually not worth wasting time arguing with them. Finish the job, bill it, then move on, reminding yourself not to work for them next time.

What is the best form of self-promotion?
Show annuals, like the *Society of Illustrators*, *American Illustration* and *Communication Arts*, are the best promotional value for the money. Of course, you've got to get into these books and that's not easy. When I first got a piece into an annual, not much happened, but after I got three and four pieces in, that's when I started getting lots of calls. I also advertise in *American Showcase* and the *Workbook*.

How do you feel the educational programs are doing in preparing students for illustration?
Nowadays, it seems the students are more focused on illustration as a career. I believe that I benefitted from my naivete. I was able to concentrate on honing my drawing and painting skills and because of that, my work has stayed a little bit more personal and less programmed.

Do you find that being an illustrator is too isolating?

That was one of my biggest concerns when I left the design firm. I had good friends there, I learned a lot from them. I saw what other people's portfolios looked like. It didn't take me long to realize that the studio really taught me great discipline. I wish there was a way for young illustrators to work at a place where they could learn, with a studio group. It's more valuable than school.

What about an assistant? Do you have one?
I need an assistant, but I don't have the time to find the right person. It would be great to have someone cutting boards, preparing packages, going to the post office, but I don't know if I want another person here in the studio. One thing I wouldn't give up is researching for reference. I enjoy going to the library and looking something up.

Throughout your career, you've been able to maintain a high level of quality in your work, while crossing over diverse areas. What does it take?
I've always tried to be as good as I could be in every situation. I don't like to have anything out there that I'm ashamed of. One rule that I live by is to ask myself of every piece I do, "Could it hang on a gallery wall?" I need to prove every time out that illustrators are not a bunch of hacks who only work for money.

(Top) Title: *Picasso's Party;* Client: *Connoisseur* magazine; Art Director: Sandy Di Pasqua. (Bottom) Title: *Delta Blues;* Client: Mississippi Delta Blues Festival; Art Director: David Bartels.

DUGALD STERMER

Dugald Stermer graduated from UCLA with a BA in both Art and English Literature. After working as a design director for studios in Los Angeles and Houston, he served as art director for *Ramparts* magazine from 1964 to 1970. As a freelancer Stermer has been a magazine designer and, for the last decade, an illustrator. Clients include the 1984 Olympic Games, Levi's, Iams Pet Food, The San Diego Zoo, Jaguar, Brooks Brothers, BMW and Nike. Stermer has also done editorial illustrations for, *Time*, *Esquire* and *The New York Times* among others.

How did you get into the business of illustration?

I discovered design in college at UCLA. I didn't draw well enough to be an illustrator, which is what I thought I wanted to be. I was a half-assed cartoonist in high school. I got that shock of recognition, and discovered design at the same time. So when I left college, I was a designer for about five or six years and then a magazine art director for quite a while. After that I was a magazine design consultant, but also starting to do some illustration. From about 1982, 1983 until now, I have been almost entirely making a living as an illustrator.

(Title) *Baby Elephants*; Client: Collins Publishing; Art Director: Dugald Stermer.

How many years had you been working as an art director when you switched over to illustration?

It wasn't an overnight switch. I'd been a designer for ten years. I used to assign myself a few illustrations at *Ramparts*, and a few at some of the other magazines I did, but I still considered myself a designer.

Why did you switch?

I didn't want an office. I didn't want employers, I didn't want to go to meetings. Also, something in me wanted to make pictures. I had to actually teach myself. I studied illustration at UCLA, but it wasn't anything that I used later on. Even though I run an illustration department at CCAC, if I had a son or daughter who wanted to be an illustrator, I'd take them to a school that had the best drawing department in the country and say, "Just take drawing classes for the first four years."

You have just begun teaching at The California College of Arts and Crafts. What are your thoughts on the education of illustrators?

I'm just flabbergasted, not only at the ignorance of the students, but the almost *resolute* ignorance of the students. It's not accurate to say that they are proud of their ignorance, but they're certainly not embarrassed by it and they see no reason to do anything to change it. To give you an example, Jim McMullan was coming out to speak at San Jose State and, as a personal favor, I asked him to come by the school and talk to the students. We put up a huge theatre poster of his in the front of the school and made a big announcement to all the instructors to encourage all of the students to go. I didn't make it mandatory. Out of a major of eighty students, probably twenty showed up. In the class that

106

I'm teaching, I told the students that I'd like to see them there. They had all kinds of excuses, "We can't get rides," "We don't know where the bus goes." And I gave them an analogy: If this was a theatre arts class and Paul Newman was coming to speak, I would expect every student in the whole school to be there and the ones who couldn't make it there, I would think, "These people aren't really serious about acting. Maybe they ought to try something else." So I have to tell you that the people who don't show up, I don't think they are serious about becoming illustrators.

Do you think there are too many illustration graduates out there? Is the market saturated?

Yes, and it's a shrinking field. But, what the hell; if a person is serious and puts in the work, there will be room.

Are the art schools focusing too much on the technical aspects of illustration and not enough on a broader, more liberal arts education?

In this particular school, they haven't focused on either one, they focused on what they called "conceptual editorial illustration." Which if you open the hip magazines, you can see the disposable illustrators, in and out, whoever is the editor's favorite at that moment, and then thrown away in six months. They are people with very few skills, almost none, but it's sort of a quasi-expressionist style. So style became a substitute for skill, at least at this school, and computers became the magic word. When I asked the teachers what they needed, they said, "More computers." And I said, "Guess what? You're going to have fewer. We're not even going to have a mandatory class in computer illustration." They were horrified. And I said, "What we are going to do is a lot of drawing from the model, objects, a lot of hand-eye and a lot of seeing. I'm assuming if these kids can't think now, that you won't teach them to think, and if they can

think now, you can't stop them by making them draw. Certainly there will be problem-related and problem-solving assignments, but the premise will be on skills, so that whatever is in or out of fashion when they graduate, they can at least address those things. God help them if what's in fashion when they graduate is classical drawing and painting. They'll be wiped out. But if they learn classical drawing and painting and they learn to draw from the model, if, when they graduate, cut-and-paste comes back in, they can do that.

How much of your work comes from editorial assignments?

Early in my career it was mostly editorial, but now I suppose it divides into 40% editorial and books, and the 60% that's left divides between advertising and institutional.

Do you get many requests for second rights to your illustrations?

Yes, some. The business of reusing drawings keeps showing up. I signed with a company in Japan for stock art. It keeps threatening to be a real factor, but it hasn't yet.

How will second rights and re-use affect the business?

I'm not going to knee-jerk and say it reduces prices. I think prices are going down but I don't think that's the reason. For example, I don't think somebody who would call up Brad Holland to get a thousand dollar re-use thing for a magazine

Title: *Minotaur*, Client: *Gulliver* magazine; Art Director: Kimiko Horiike.

Within the illustration: *CHRISTY • MATHEWSON*

"A pitcher must always have an alibi to explain why you lost. ...But keep it to yourself, that's where it belongs."
—MATHEWSON

Mathewson was among the first five players to be elected to the National Baseball Hall of Fame.

"It was wonderful to watch him pitch, when he wasn't pitching against you."
—CONNIE MACK

« BIG SIX »

(Above) Title: *Christy Mathewson*; Client: Consolidated Paper Co.; Art Director: Leslee Archen. (Right) Title: *Buffalo*; Client: Sedgwick County Zoo; Art Director: Reuben Saunders.

page chooses between him and somebody equivalent to Brad to do a new piece. I think what they are probably choosing between is Brad giving them that piece or some newcomer copying Brad. I'd rather the stock illustration market took off than have the situation where a bunch of young illustrators were encouraged to imitate, if those are the options.

Are fees and pricing standards getting better or worse?

The market is shrinking and fees are getting smaller. In my experience, some of the best people in the illustration field are art buyers in big advertising agencies. They have no personal stake in the money aspect. It isn't their money and they've been told by the art director to call someone. What they usually say is, "Can you do this job for X dollars? That's what we've

got." Some of the book people, supposed good guys, will go all the way around the map and not tell you what they've got in the way of money, so you tell them three thousand dollars and you never hear from them. You don't know whether your price was too high or whether they went to someone else to do it.

How is your business set up?

I have a studio separate from my home. I spend all day there except when I'm teaching. In the last year and a half, my daughter, who is an actress and working to get her career off the ground, works with me four hours a day. She does the bookkeeping, a lot of reference-hunting, fields phone calls, does all the stuff that I wonder how I had time to do before, like entering shows, occasionally sending books and the like.

Earlier, you mentioned that you had a rep. What kind of arrangement do you have with him?

I've had a rep for about eleven years, the same one. Jim Lilie is his name. He has a small group, and he's here in San Francisco. I have no other reps. He hasn't taken anybody new in some time. He's of the old

school that says, "If I'm really doing my job right, I don't leave my office." He sends books out all over the country on request and he sends out mailings periodically. His commission is twenty-five percent across the board. The reasoning is that he does the promotion and he pays for it. The only part of promotion that I do is entering the shows.

How do you feel about reps? Do you have a positive attitude toward them?
I've been asked by New York reps who see my work around if they can represent me, and I have always resisted the idea of having different reps in different cities. You lose control of your business. And I also think reps tend to try and make you something you're not, like one of those marriages where they just love you to death and then try and change you. Jim's never, ever done that.

What are your thoughts on self-promotion? How do you promote yourself?
I enter *Communication Arts Illustration Annual*. You enter a piece and it costs fifteen or twenty dollars to enter, so you enter ten or fifteen pieces and the jury takes two, and the audience of sixty to eighty thousand sees it for years. And then the *Showcase* backs it up. I've been in the *Showcase* now for about ten years. Art directors seldom see a piece in its original incarnation—an ad, or a book, or a magazine page. They usually see it after it appears in an annual or in the *Showcase*.

How do you deal with art directors? Having been an art director yourself, you probably have a different point of view than other illustrators.
I probably don't. My idea of an art director is how I used to work, which was: I would call up somebody like Seymour Chwast or Milton Glaser and say that I have a manuscript that is appearing in the magazine and tell them what it's about. "Do you think you want to do it?" They would say

"Yes," and I'd send them the manuscript and say, "Have fun, you've got a page, or if you want to take a little more than a page, let me know." That's the way I art direct. That has really disappeared. For example, I got a call from a book designer who wants me to do a cover on a subject that I've done a lot of work on and I know something about and it's interesting to me. It's on the interdependence of species on islands. So I thought, "What a terrific opportunity." And she said, "Now, what we want is type centered on the page, and we want a bird in the upper left, a flower in the upper right, a fish in the lower left, and a mam-

mal in the lower right." I said, "Wait a minute. Hold on. I'm not objecting to doing that particularly, but the symbolism that you could get into this cover is so great," and she said, "Look, this isn't like the old days." I said, "Well, okay, how about I just do what I'd like to do with it and the only obligation you have is you show it to the editor and whoever else?" And she said, "Okay, that's fair enough." So that's what I did and I haven't heard back.

Do you enjoy being an illustrator?
When I'm busy, there's nothing like it. I love bouncing from different assignments. I'm learning all the time. It's fun. I sit here for hours and hours and the day goes by and I'm listening to music and I'm totally into it.

(Top) Title: *Great Slug*; Client: Collins Publishing. (Bottom) Title: *Butterflies*; Client: Simpson Paper Company; Art Director: Kit Hinrichs.

The Art of Self-Promotion

An art director's office is a veritable disaster area somewhere between a child's playroom and a town dump. Picture this: A desk besieged by paper; table tops stacked with files, folders, manuscripts, layout boards and God knows what else hidden underneath; flat files stuffed with junk dating back to the year 1 B.C. (Before Computer); shelves overflowing with books large and small, perhaps a forgotten muffin or two; and walls bulging with posters, pictures, and scores and scores of artists' promos—not just any promos, but the very best ones. Yes, even the best can fill entire walls, file drawers and boxes.

If you still think that your drab little self-promotional card with that meager black and white reproduction of what you must think is your cleverest work is going to get noticed, think again. The number of self-promotions that the average art director or art buyer receives on a weekly basis comes perilously close to the amount of junk mail received weekly by the average American. For some art directors artists' promotions are, in fact, little more than junk mail. So what's an illustrator to do?

Plenty.

Self-promotion must be every bit as creative as illustration itself. Although there are formulaic-looking cards, an artist's promotion should be anything but formulaic. In fact, these cards, booklets and flyers are critical to business success since face-to-face interviews with art directors are rare. Their purpose, therefore, is to conquer the art director's heart and mind. Without promotion that attracts immediate attention, sticks in the memory and stands out on the art director's wall, the illustrator is an invisible presence, as likely to get a job as fish will grow feet.

Clever promotions do get reasonable, if not sometimes excellent results. Amy Guip (see interview on page 96) says that she still finds her first cards tacked up on art directors' walls. Many art directors admit that with so much visual stimulation around them everyday, a good promotion is the only viable reminder they have. Promotions are worth the effort, but the results will only be commensurate with the amount of effort put into them.

Of course, there are exceptions to the rule. Brad Holland (see interview on page 74) has never produced self-promotional materials or even taken out the smallest ads in the myriad promotional books. Instead he entered work in and was selected for all

ration look through *HOW* magazine's annual self-promotion issue. Every year illustrators come up with novel ideas that exhibit their talents, intellect and ingenuity, from putting work on computer disk or CD-ROM to distributing quirky little souvenirs. For example, years ago Leslie Cabarga had pencils manufactured with his name and telephone number on them. Every time an art director wrote a message Carbaga's name flashed

(see interview page 92)

(Above) Gary Baseman's stationery and promotional card packet is a roughly hewn but consistent identity. Illustrator: Gary Baseman; Designer: Tod Waterbury, Tod Waterbury Design. **(Below)** Elegant and simple characterize Stephen Alcorn's stationery, mailing labels and business card which includes an original linocut titled *The Troubador.* Illustrator/ designer: Stephen Alcorn.

the major competitions. Likewise, Guip insists that the bulk of her work comes from other published work. But these experiences are anomalies. When looking for work most illustrators must create some kind of promotional medium, if only to remind art directors of their existence. Even Henrik Drescher (see interview page 92), who denies ever formally engaging in a concerted self-promotional campaign, has created scores of hand-made, mail-art and Xerox books which, in the early part of his career, were sent to friends and art directors and were undoubtedly the reason he received so much attention. That they were handmade books gave them cachet, that the examples were more like sketchbooks than a portfolio of slick printed works gave them allure.

However, it is rare, though not impossible, that a mere promotional card will make waves. Nevertheless, ambitious promos *will* get noticed. For evidence and inspi-

into view. Thomas Kerr printed notepads showing different drawings to remind the note writer of his work. Similarly Ross Macdonald sends out personally illustrated desk calendars with easel backs like the local bank or neighborhood garage. Art directors who use them can't avoid Macdonald's hypnotic presence. Even more brazen are those like Gary Baseman who have sent out promotional t-shirts. Not only do they serve as reminders but they telegraph the illustrator's name to the world. Certain illustrators, presuming

(Top) James McMullan's personal logo, a walking man rendered in watercolor, is used on his stationery and mailing materials. For a moving announcement he added an extra prop. Illustrator/designer: James McMullan. (Center) Frank Viva's ambitious stationery program includes a collection of eyecatching stickers that can be used in various combinations on letters, disks and bills. Illustrator: Frank Viva; Designer: Frank Viva, Viva Dolan Communications & Design, Toronto. (Bottom) The stationery program for cartoonist/illustrator Elwood Smith shows a collection of his delightful characters. Illustrator/designer: Elwood H. Smith.

(Top) Adam McCauley has an official billhead while his business card and promotional mailer are more playful. Illustrator/designer: Adam McCauley. (Center) David Plunkert's identity system ranges from cards and envelopes to an impressive promo card package. Illustrator/designer: David Plunkert. (Bottom) James Kraus' stationery has a variety of different sized and colored cards and letters accompanied by a handsome chapbook. Illustrator: James Kraus; Designers: James Kraus and Fritz Klaetke.

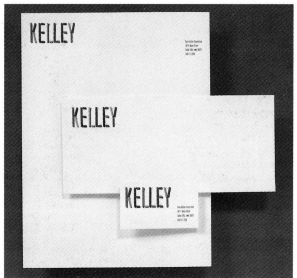

that even the most callous art director would have to think twice before throwing away an original work, send out drawings or limited edition prints. Every time an art director wavers before disposing of a promotion the artist's name becomes more memorable. Mailing envelopes are also a frequently used vehicle for original promotional art. Colos, an Eastern European illustrator with a popular style, drew bodies below the stamps on his envelopes. The images were so witty and clever that art directors who received them were compelled to tack them to the wall. Moreover, in the clutter of anonymous envelopes, the personally illustrated one can be a real eyecatcher.

Coinciding promotions with seasons, holidays or special events is another common strategy. While Santa Claus brings gifts for good little boys and girls, the United States Postal Service delivers art directors Christmas cards by the truckload.

The downside, of course, is that Christmas is not the most propitious time to grab anyone's attention. While Santa has hundreds of elves to keep track of his correspondence, the average art director probably has no help whatsoever. The Christmas season is usually when editorial and advertising art directors are the most crunched, so even the best Christmas cards may get tacked on a wall for the duration of the holiday, but otherwise ignored. Halloween is the next most popular holiday for illustrators, and not surprisingly offers even more creative opportunities. However, with too many greeting cards competing for attention even the better ones can get edged out. If an illustrator wants to do a seasonal or holiday project, it's wiser to pick those times when cards are unexpected, like Veterans Day, Simchas Torah or National Secretary Day.

There are, however, limits to creativity when the promotion(s) are a nuisance. Amidst exces-

(Left) Michael Bartalos uses many iconic comic characters in stationery that is at once boisterous and alluring. Illustrator/designer: Michael Bartalos. (Right) Gary Kelley identifies himself with pastels that combine to spell out his name. While this does not highlight his drawing style, it is nevertheless delightfully eyecatching. Illustrator: Gary Kelley; Designer: Mike Schroeder.

(Top left) Seasonal promotions are quite popular. Linda Bleck's Halloween diecut promo, rendered in scratchboard, unfolds into a candle holder. Illustrator: Linda Bleck. (Top right) Amy Guip's illustrations are collected as a box of postcards titled New York, a great gift and promo. Illustrator: Amy Guip. (Center) A good calendar can be a year-round way to show off work. Here are examples by Ross Macdonald (left), designers: John Pylypczak, Diti Katona/Concrete Design, Toronto; Rafal Oblinski (center), designer: Ann Murphy; and Steven Guarnaccia (right), designer: Scott Christie/Concrete Design, Toronto. (Bottom left) Thematic promotions make good gifts. Sandra Dionisi's deck of real playing cards is a great showcase for her work. Designer: Sunil Bhandari. (Bottom right) With a varied collection of sizes and shapes Sandra Dionisi has a promotion card for every occasion. The novel variations build an expectation in the recipient for an exciting series of promotions. Designers: Barbara Woolley, Bob Hambly/ Hambly & Wooley, Inc., Toronto. Her Christmas cards not only offer holiday cheer, but sell her talents, too. Left and center, designer: Sunil Bhandari; right: Christopher Noble, Nobleworks.

sive competition the tendency to go overboard should be avoided. One rather common occurrence is the envelope that contains confetti guaranteed to spill onto everything. The recipient of such an unwelcome gift will doubtless ignore the card and the artist's effort will be for naught. Another unwanted trope is the gimmicky jigsaw puzzle which when and if a recipient puts it together reveals a promotional message. While in theory this might seem like a fun idea, no art director or art buyer has the time to play such games. There are many such whimsical ideas that take time, effort and money to produce but owing to their complicated nature will yield little return.

The best way to promote oneself is often the simplest. Less is more when handled with taste, intelligence and, above all, self-respect. The latter is the key. It doesn't matter what the form—a card, flyer, booklet, portfolio, folder, etc.—if it reveals the ability of its maker to control his or her work. This implies that whatever goes into the promotion should be thought out. If the promotion is a single item, it should be the very best. If it is

(Top) When Jeffrey Fisher decided to move from Australia to France he created a mini-Ouija board to comically show his comings and goings. Illustrator/ designer: Jeffrey Fisher. (Below) Mark Ryden's neatly packaged cards not only indicate the range of his talents but the fact that he understands the power of good design. Illustrator: Mark Ryden.

a series, it should represent intelligent editing. Presentation should not be underestimated. Illustrators without typographic skills should hire a graphic designer to select and compose the type, design a personal logo, or fabricate a total package. For some illustrators having a custom designed "identity" is every bit as useful as exhibiting a graphic persona through the work. An identity provides a framework for future promotions. It is a clear signpost that becomes familiar to art directors and art buyers over time.

Advertisements for Myself

A SCORE OF ANNUAL PROMOTIONAL books, paid showcases for illustrator's advertisements, are available to anyone who can afford them. Some are used more than others by art directors and art buyers, some illustrators and their reps swear by them while others swear at them. It is a fact of business life that pro-

ILLUSTRATIONS FOR SALE

ILLUSTRATIONS ARE NOT created for the artist's personal satisfaction and artistic expression or to be hung on a wall, but rather to enhance an idea or to communicate a message. Notwithstanding, from time to time, an illustrator might receive a call from someone who'd like to buy an original piece of art. Not only is it flattering to have your work seen, enjoyed, appreciated and coveted, but the addition of the unexpected income derived from its sale can also be a nice surprise.

For the last three years, contemporary illustration has appeared in the sales rooms of the Drouot auctions in Paris, at the impetus of chief auctioneer, Claude Boisgirard and of his assessor, Frédéric Bosser. Recognizing the appeal of a piece of art that had a first life as it appeared in the media, possibly adding more meaning to it by connecting it to an event or a time and a place in the world, Bosser gathers together a collection of international, contemporary illustrations for sale to the Parisian public.

The presentation of these works is in the form of a catalog-box stamped with the date and the place of sale, which includes 140 works, all reproduced in color on separate cards on the back of which are written the biography of the artist, the estimated value of the piece and the description of the work.

Sixty or so illustrators are "invited" to participate anywhere from one to four pieces of art, totalling 140 pieces in all. The artists are required to pay 200FF to help with printing costs. In return, they receive 200 cards printed on one side (to be used as promotional items), as well as

Auction catalogs in a box. Art directors: Steven Jinel, Frederic Bosser; Designer: Steven Jinel.

the sale price of the work, minus the commission.

Some of the illustrators who have participated in this adventure are Alberto Ball, Guy Billout, Seymour Chwast, Christopher Corr, Normand Cousineau, Brian Cronin, Robert De Mitchiell, Isabelle Dervaux, Blair Drawson, Jeffery Fisher, Douglas Fraser, Carolyn Gowdy, Steven Guarnaccia, Jeff Jackson, Benoit Jacques, Martin Jarrie, Lionel Koechlin, Anita Kunz, Paul Leith, Jacques de Loustal, Richard Merkin, Cathy Millet, José Ortega, Richard Parent, Ian Pollock, Pierre Pratt, Robert Risko, Mark Ryden, Pol Turgeon, Walter Van Lotringen and

Philippe Weisbecker.

The first auction, which was held April 6, 1991 (there have been five more since), only presented artist's originals of "bandes dessinées." The concept has evolved bit by bit and now comprises the works of illustrators and cartoonists from the entire world including Argentina, Australia, Belgium, Canada, United States, France, Great Britain, Holland, Spain and Switzerland. Bosser and the artists choose the pieces and establish a minimum base price under which the piece cannot be sold. Expenses add up to about 12% (10% plus taxes), to which is added an entry fee of 250FF per work.

More than two hundred people have attended each of these sales, with the number of actual buyers ranging from forty to sixty. The purchasers who buy the most works are between forty and sixty years of age, and the majority of buyers are between twenty and thirty five years old. Seven hundred to eight hundred people visit each exhibition. The works are offered at prices ranging from 700FF to 2,000FF. The high quality of the works offered at reasonable prices allows everyone the chance to purchase a great illustrator's work.

Information: Frederic Bosser, 22 rue de Beethoven, 91700 Ste. Genevieve des Bois, France; Telephone: (1) 60 15 55 89; Fax: (1) 42 47 05 84; Auctioneer: Claude Boisgirard, Étude Boisgirard, 2 rue de Provence, 75009 Paris, France; Telephone: (1) 44 70 81 36; Fax: (1) 42 47 0584.

motional books can make an important difference in getting work. If the presentation is exemplary and attention-grabbing, the odds are in favor of earning a decent return on the investment.

Not all illustrators need to have paid advertising, but those who are looking to expand their client base beyond their locality and/or into other media should

takes more effort to do something original, the investment in time and labor is certainly not going waste.

A vast majority of young and veteran illustrators alike may have a body of work that has not been seen on a national level. In this context it is a good idea to show the best samples of the year. Moreover, with the increased demand for reprints,

(Left) Jean Tuttle produced a "The Day of the Dead" handkerchief to celebrate the Mexican festival and promote herself. Illustrator/ designer: Jean Tuttle. (Right) The smell of coffee lured potential clients to Jon Valk's lettering studio. Illustrator: Jon Valk; Designers: Jon Valk and Anna Walker. (Below) To promote his children's book and his style, J. Otto Seibold produced Mr. Lunch airplane soap. Illustrator/designer: J. Otto Seibold.

think carefully about making the often expensive investment. For those in margins, it is probably worth testing out an ad at least once. If the decision is to go with an ad an illustrator should pay careful attention to what the advertisement looks like. Remember these books are akin to shopping malls with scores of competing merchants screaming at prospective customers to sample their wares. It's easy to get overlooked in such an environment as styles will invariably clash. An illustrator should be careful to select just the right balance of work, or better yet devise something special for the page(s). Every year Elwood H. Smith, a gifted cartoonist/illustrator, invents an original comic tableau to show a sample of existing work. Smith's first one was titled "How To Draw Cartoons Like Elwood H. Smith," a theme he has continued to develop. While it

interest may be generated in reusing this existing work.

Bear in mind that some promotional books are aimed at certain regions, while others are national in scope. Not every illustrator should compete on a national level— sometimes it's best to start regionally to allow one's work to mature. Don't set your sights too high or spend too much on a national ad before determining your own viability. Also, before buying into one be sure to investigate the success rate of the particular book by talking to others who have taken out ads. While learning from mistakes can be useful, it's better to avoid some of the

(Left and below) The quirkier the better for Henrik Drescher. His portfolio is really a scrap book filled with ten years of tearsheets and random original art. For good measure and a distinctive patina, he threw it into a filled bathtub.

stupider mistakes at the outset.

Most promotional books offer overruns or special printings of the page(s) either as part of the basic fee or for an additional charge. For those who cannot afford to print separate promotions these pages are quite useful as mailers or leave-behinds. In any case advertising can be beneficial if used cleverly and intelligently. But even advertising is not a panacea; an illustrator is only as good as the work he or she is advertising.

The Portfolio Is Key

THE PORTFOLIO IS A SAMPLE CASE. Maintaining a good one is the key to success and should not be underestimated or overlooked. Despite the emphasis given portfolios in art schools and illustration courses it is dumbfounding what a large percentage are poorly designed and edited. Among the worst are the manila-envelope and brown-paper-bag variety. Though hard to believe, some wannabes deliver their work as if it just came from a quick copy store. Given the amount of competition, that's plain stupid. Even if a wannabe illustrator gets a rare face-to-face interview, presenting a bag-o-drawings is a turn-off that suggests unprofessionalism and a lack of seriousness.

With all the different kinds of portfolio cases on the market and the potential for unique custom-made displays, an illustrator does not have to resort to ad hocism to be perceived as different. Throw away the manila envelopes, accordion folders and other clerical stationery supplies. Do not put work in a loose-leaf notebook or photo album. And please reject the impulse to

(Left) Drescher also uses small, handcrafted booklets to supplement his portfolio. In a sea of conventional books, these are islands of invention. (Below) Though conventional, Anita Kunz's portfolio is well orchestrated. Included are a score of matted 4×5 transparencies, promotional cards and tearsheets.

matte every original drawing. What art directors and art buyers want—and what artist's representatives encourage—is a simple case of manageable size and heft, easy to open and close, that keeps the originals or tearsheets protected. Within these elementary parameters a portfolio can then be made of a variety of materials—leather, suede, aluminum, reinforced board, etc.— and come in numerous forms—briefcase, archival box, book, etc.. Most are basic black, some have a logo pasted on or a name embossed on the front. If standard portfolios do not suit one's personality there is a variety of custom-made options. A good portfolio does not have to be drab, but should not be so excessively encumbered that an art director is afraid to handle it lest it be broken. Keep in mind that a portfolio might be handled as much, if not more than, luggage at an airport.

The standard portfolio contains protected sheets or pages that should reveal work as either originals, copies, tearsheets, or transparencies. Depending on the illustrator color might be shown with black and white; published might be shown with unpublished; sketchbooks might be included with more formal work. Whatever the nature of the material, an organizing principle is important, such as all editorial kept together or comparing the original alongside the printed version. Some illustrators maintain separate folios for published and unpublished, black and white and color, editorial and advertising, or adult and children-oriented work.

While such principles should conform to the artist's personal preferences, there are a few rules of thumb. For example, the most confusing organization is where two or more differing styles are shown together. Since the portfolio must quickly and concisely represent an artist's abilities it is best to differentiate between various styles by segregating them in some manner. Different genres will benefit by segregation also. If the illustrator is interested in doing more book jackets, that work should be

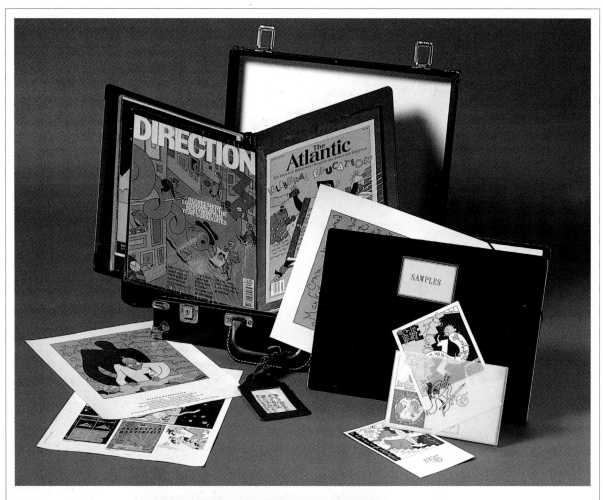

(Above) Steven Guarnaccia prefers printed examples which he puts in two vinyl books. Also included is a cardboard folder with a variety of leave-behind samples. (Right) Steven Guarnaccia's first sketchbook exhibits the naivete of a neophyte but the roots of his professional work are already apparent.

separate from, say, editorial illustration, and so on. A portfolio will benefit from being edited like a book where pacing work is essential. One might start with the most striking or emblematic piece on the opening page, then show a couple of comparable ones on successive spreads, evening out on the next spreads, then building to a crescendo by the end. Every portfolio will be different, but keep in mind that every portfolio should be consistently interesting.

Unconventional portfolios are sometimes the most interesting, if only for their form, but to sustain interest the work must be as good if not better than the presentation. Hence, an unconventional portfolio should not overpower the work but complement the artist's vision. Henrik Drescher's "portfolio" is a constantly growing sketchbook that speaks volumes about the artist's method—and madness—but is not necessarily the best way to present work for those illustrators even with vision. Some of the most effectively quirky portfolios are those that toe a fine line between eccentricity and professionalism with just the right balance between the personal and unconventional approach. A hypothetical example of this

neutral in allowing the work to speak for itself or demonstrative in supporting the artist's persona. Those shown in these pages range from seemingly anarchic to professionally stolid. The common thread is that they have all been prepared with attention to the market these illustrators want to appeal to and the terms on which they want to be accepted as artists. Which-ever course is chosen, the portfolio should be critically reviewed as often as possible by the artist. The contents should change as new material becomes available, but also if the flow or pacing doesn't quite work. The portfolio is the illustrator's most valuable business asset and should be treated with the same care and mainte-nance afforded to any other tool.

(Clockwise) Gary Tanhauser's portfolio is an elegant custom-made book with plas-tic-laminated tear-sheets that have been mounted on black. The electronic portfolio is quickly gaining in pop-ularity. Nancy Stahl's is two Mac diskettes that approximate the traditional slide show. David Klug's portfolio is a spiral bound sketchbook with print-ed copies of his work. It also serves as an im-pressive leave behind.

might be a series of ten transparencies of solid work in addition to three or four handmade books showing anything from sketches to fully realized stories. If the ten transparencies capture the art director's attention, then the quirkier material will reinforce the artist's personality. Therefore, in the balanced unconventional portfolio the viewer is guided first to the profession-al content, then to the other.

In the final analysis a portfolio can be

The Rep

Not every illustrator needs or wants an artist representative, but everyone should at least consider having one. Even if they want one, though, not every illustrator can get a rep. The best reps have standards that most wannabe illustrators will find hard to meet right out of school. Before considering whether you want a rep or not, you should determine whether a rep wants you, and if not, why.

Reps are on the front lines of business and know what the market will bear and reject. They understand the stylistic ebbs and flows and possess a certain artistic sophistication. The best adhere to certain business standards while also developing their own particular strategies. A rep's vision is usually narrowly focused on market needs, and so a potentially exceptional artist may be rejected because the work does not fit into that rep's specific area of expertise. Nevertheless, reps are bellwethers of current fashions and trends and styles. Moreover, they are cautious conservatives in a highly competitive creative business where most artists throw caution to the wind.

A good rep is one who understands the needs of his or her artists and the wants of the market. An ability to wed the two is key to a rep's success. A rep is also a mediator between artist and business, alternately a matchmaker, referee, negotiator, conciliator and interpreter. At once a champion and critic, the rep is often the closest associate an illustrator has. In such a context the rep is the authority figure in the illustrator's life, both ally and enemy of the artist's real muse. Depending on the artist's expectations a rep can be the wizard of wealth or demon of destitution. Often reps are expected to work miracles. One must accept that the rep is not a father or mother but a business person who operates under established parameters. To avoid a muddled relationship, then, an illustrator should initially examine what is truly wanted and expected from a rep.

Before entering into a relationship that places demands on each party, both should accept what the other is willing to provide. In addition to the checklists of what an illustrator might look for in a rep and what a rep looks for in an illustrator, this section features interviews with three artist representatives whose differing experiences and strategies offer the reader a chance to sample various options. There are many different kinds of reps, from high- to low-powered, from proactive to passive, from knowledgeable to ignorant. Some reps work in very large agencies with staffs of sales people, while others are in small shops with one principal. Deciding whether representation is necessary, and selecting the right individual or group, is one of the most important business decisions an illustrator can make.

FRAN SEIGEL

A member of SPAR and the Graphic Artists Guild, Fran Seigel is in her 14th year as an artist's rep. Seigel represents a group of seven artists who work the full spectrum of the commercial market including editorial, book jacket, corporate, advertising, children's books, educational, packaging and posters. Artists represented are: Kinuko Y. Craft, John Dawson, Catherine Deeter, Hokanson/ Cichett, Larry McEntire and Dan Sheberger. Seigel has an ongoing interest in the area of artists' business competency, especially in the importance of negotiating limited rights and the related growing area of secondary rights sales and/or stock illustration.

How did you become an artists' rep?
I started with Artists International. After two years I was ready to go on my own. I represent seven illustrators. I am a "boutique rep," which means I handle a small group, so the focus is on the artist.

Is there a standard commission fee for artists' representatives?
Yes. Since the rep's association is often involved, all reps who I know, members and non-members, charge a minimum of 25%. Some do what I do on low paying jobs—I use a sliding scale, of minus 5 or 10%, if it will benefit the portfolio and then both of us.

Do you get a commission on everything an artist does, even if they have established clients already?
Some have non-interfering accounts: they come to me with clients, I don't take commission on anything that I haven't done.

What if an artist gets a call from someone who's heard of them indirectly from your work?
It's an act of faith. Often an artist will get calls from someone who knows their work and they'll have the choice of turning it over to the rep, or not.

Are all your artists working regularly?
Occasionally we get a situation where one artist will have a banner year, making $19,000 on advertisements, and the next is only $1,400. We make it up by going after new clients.

Have you been disappointed by an artist turning down a job that you felt would have been really advantageous?
Generally, no. An artist always should do what excites them. If an artist turns down

Sample sheet from Fran Seigel's promo kit. Illustrator: John Dawson.

a job, I want to know the reason for the refusal. Possibly we need to discuss and re-align motivations.

Do you ever have a situation where your artists are competing for the same job?
It's rare. The styles of my talent are distinct enough that direct competition doesn't really occur.

Some illustrators say that they don't have reps because they don't want to be talked into doing jobs.
It's like any relationship. Whenever one person is bending so that another is spared a difficulty, it makes problems somewhere else. It's important that the artist and the rep both feel it's a win-win situation.

Some illustrators say that reps aren't interested in editorial because there's no money in it, advertising and design is where the bucks are.
A lot of reps are getting an increased appreciation for editorial because it affords visibility.

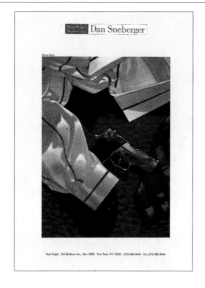

Sample sheet from Fran Seigel's promo kit. Illustrator: Dan Sneberger.

Do you ever make suggestions to the artists regarding finished work?
I suggest types of portfolio samples. Almost all my artists have done samples just for me.

What about the possibility of a job not being suited to the illustrator. How do you handle that?
I have a pretty good idea of what the artist can do. If a call comes in and it's nothing

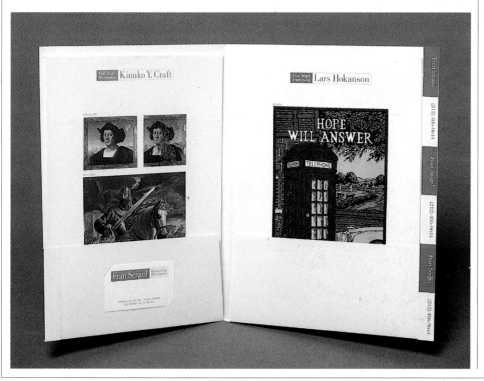

In Fran Seigel's promotion book illustrators are represented by one or more pieces of work which she mails out to art directors. Page design: Paula Scher/Pentagram; Folio design: Fran Seigel and Ron Louie/Pentagram.

like what the artist has done, I'll tell them. If it's something I think the artist will enjoy, I'll try to get the job.

Is there a certain promotional medium that works best for you?
Now there are eight or nine quality directories. Artists really have to be more targeting in their promotions, which for us has meant going with fewer images.

How frequently do you send out mailings?
I do them about once a year. For advertising, I send mainly to the top buyers, editorial are usually repeat clients, for book publishing the seasons are January and September, and corporate clients are in August.

Do you do anything else for promotion other than buying pages in the directories and mailings?
I'm doing a folio now that might be a promotion folder. We have

done Christmas cards. Now we are doing postcards. I don't think it's possible to get very high exposure unless you're in major magazines.

What competitions do you enter?
CA is the best.

Have you noticed any change in the illustration business since your early days?
Years ago you could carry a book around and get jobs, but not anymore. There's more competition, there are economic factors and there's new technology. Advertising clients are bottom-line focused and ask their agencies to use stock or just design with no art, so there are less advertising jobs. Also, in 1980, it was a regional and national market, but now it has moved to a global one.

What about pricing and negotiating?
I think it's unfortunate that clients think we pull numbers out of the air. People have to understand that there are reasons for a price.

What is the minimum that you would accept for a job?
I have three or four artists with minimums of $400. We have editorial jobs with conceptual freedom for $450/year. Kinuko Craft is well established and always booked, so her minimum is $2,500. If she really loves the subject, we'll try to fit it in. $12,000 or $13,000 is the most I've gotten for one painting.

What would you say is the most difficult part of your job?
The weight of an artist when they're really in a lull. When the images aren't there, when there's no work.

Personal Contact

I don't really believe in using reps. I feel that 25% of the income going to them is way too high for what they do. More to the point, illustration can be a relatively solitary lifestyle. The more direct contact with the outside world, the better. Meeting art directors or clients is one of the few chances one has to connect with other people. I enjoy it.
—Blair Thornley

FINDING A REP

A perfect match between artist and rep is not always easy. Finding one could take several false starts. Following are some guidelines for choosing a rep:

- How many years have they been in the business? Are they experienced at pricing and negotiating? Are they active globally?
- What services do they offer? Bookkeeping, invoicing, tearsheet collecting?
- How much of a commission do they take?
- Does this person have a good reputation with clients and art directors?
- Is there a genuine understanding and appreciation of your work?
- Who else does this person represent? How does your work and approach fit in?
- Is their client base an area you have yet to pursue or is it similar to your existing clients?
- What kind of an arrangement do they offer? Is it exclusive? Can you keep your house accounts?
- What kind of promotional programs are you expected to participate in?
- What does their corporate identity look like? Would you want your work associated with it?
- How often will you be paid? As soon as each check arrives or once a month?
- Will you be involved in deciding what goes in the portfolio?

FINDING AN ARTIST

W hether a rep is seeking new artists or being approached by an interested illustrator, he or she must consider the risks and the opportunities of taking on someone new. Since the artist/rep relationship is not a one-way street, here are some questions that could arise:

- Why do you need a representative?
- Do you see yourself as a business?
- Do you make a viable living as an illustrator?
- How much of an income do you need to live comfortably?
- Are you an established illustrator looking to rejuvenate your business or are you just starting out your career?
- What do you expect this partnership to do for you?
- Does your style conflict with that of any of their other artists?
- What markets are you interested in pursuing? Are you flexible about trying new ones?
- Are you responsible? Do you meet your deadlines? Are you trustworthy?
- How do you deal with clients? Do you have a good business manner?
- Are you willing to hand over the management of your house accounts?
- How do you handle corrections and changes from clients?
- Are you a professional? Do you always give it your best?

(Left) The Art Rep package is designed for easy access and storage. (Right) Jacquelline Dedell produces annual promotion books to showcase her client's work. Designer: Sibley-Peteet.

RICHARD SOLOMON

Richard Solomon's father was an art collector and partner in an art gallery in Greenwich Village, so he had been exposed to art since childhood. He attended The High School of Music and Art in New York City, but originally wanted to be a marine scientist. After a brief stint as a photographer's rep, initiated by a dare from a photographer friend, he realized he was better suited to illustration. He has been an artists' rep since 1982. Currently, he represents fifteen artists, some of whom are Steve Brodner, John Collier, Paul Cox, Gary Kelley, Skip Liepke, C.F. Payne, Douglas Smith and Mark Summers.

Had you worked for another artists' representative before starting your own business?
No. Everything I did I learned by trial and error. To give you an example, I was the first one to represent scratchboard commercially. When I saw the work of Douglas Smith, I was very excited about it and went to a few of my colleagues and said, "What do you think about this?" And they all said, "Oh, well, it's very nice but you won't make a dollar doing that." I didn't listen. So now I represent four scratchboard illustrators. It's the most lucrative area of my business.

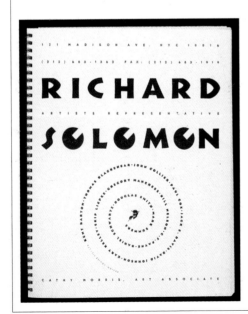

Opening title page to Richard Soloman's promo book. Designer: Louise Fili.

How many artists do you currently represent today?
In the last five years I have represented somewhere between twelve or fifteen artists. This is a comfortable number for me.

How much do you handle of their everyday business matters?
Everything is done here. I have exclusivity with all my talent. All the billing is here. All the check collection is here. We even enter the contests for most of the artists.

So your bottom line is?
The bottom line is my job is to get jobs for these people. I position the talent, which usually takes about three years. After three years you should have either a star or a star-in-the-making. In the first year you make too many mistakes. You need that first year to get feedback.

How much commission do you make?
I'm on 30% commission. That is also true for the illustrators I represent who are out of the United States.

How much of the work you get is editorial, corporate, advertising, books, etc.?
Every artist is unique. Chris Payne is doing more editorial and will always do more editorial. Mark Summers can do tons of editorial, but he's seen as the logo guy. Everything develops in terms of who the individual is.

How do you go about choosing an artist to represent?
It's visceral.

Do you ask your artists to do samples for

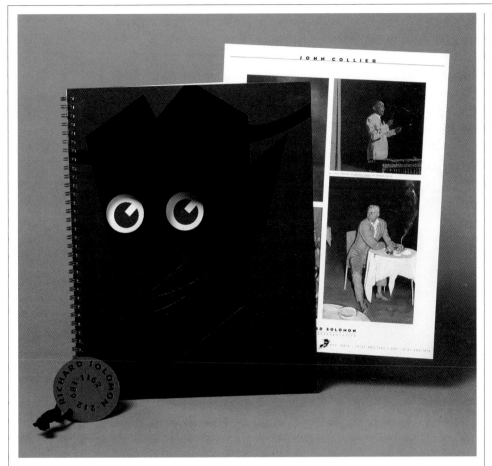

the portfolio?

Sometimes I'm the art director. I like working with the artist on both the portfolio and, more importantly, the promo kit or book that we do every couple of years and the pages in the *Showcase* and the *Workbook*. I don't conceptualize the art, but sometimes I do conceptualize the *concept* from a marketing point of view.

Are all the artists you represent male?

They are at the moment. I have represented four or five women during the course of my career.

Would you say there are more women art directors than men in the business?

Much more. And they're better. There's less ego involved.

What do you do for promotion?

I have a double-page spread every year in the *Showcase*. At the moment, because we're only in our first year of the *Workbook*, I went in with one page. I might go to two. Then I have my direct mail piece which Louise Fili designs. We do that every two years. I consider the *Society of Illustrators' Book*, the *Communication Arts Illustration Annual* and the *American Illustration Annual* advertising. And I've had the last three covers of the *Society of Illustrators Book*. Everything helps.

Do you have an annual plan for mailing your promo kit?

The last two books we did, I sent out ten thousand copies. I use the Steve Langerman list. He's the best in the business. I do fairly blanket coverage in the New York area and then target certain cities and agencies in the United States. I've also developed my own list of anybody who's ever given me a job.

DAVID JOHNSON

Left: Samples of Mark Summers' work from the promo book. Right: The back of Richard Solomon's promo book features a pocket holding various, loose sample sheets.

What about international?
I only send them based on calls that come to me. It's prohibitive just to throw it out there.

Do you get very involved in the portfolio presentations?
Yes. The portfolios are my babies. Our portfolios are constructed in a positive, manipulative manner to show the best that this guy does.

Do you change the work in the portfolios often?
Yes. If something new comes in that's fabulous we try to get it in the book. But I would say that once a year they get a thorough review. If the artist has some terrific stuff and it's a mature portfolio, I show forty units, twenty pages on two sides.

Do you find it helps to appear in high-profile magazines?
Yes. I think this is very important. Reps are very focused and they don't realize that the editorial drives the advertising.

What are your thoughts on dealing with art directors? Do you have problems getting the tearsheets and originals back?
It's pulling teeth to get the tears because art directors are swamped. We cajole, we nudge, we say that we need it for the contests, which is true. That perks them up most of the time. As far as getting the original art back, it comes back sooner or later, and if it doesn't, we make the calls. If it gets lost they pay for it—triple damages. It's in the invoice. It's ironclad. It's not negotiable. All my paperwork is tight as a drum.

What is it about this business that you enjoy the most?
I like getting up every morning and doing something different. I'm not bored with what I do. I love the people that I work with. I've become successful and haven't sold out.

> ### Rep Relations
>
> The relationship with a rep is like a marriage: a lot of arguing, a lot of giving and taking and hopefully a ton of mutual respect. It helps tremendously if both parties know each other's potentials and limitations, skills and, above all, temperament.
> —Phil Adams

AGENTS WITH A MISSION

Reactor Art & Design Limited is a design and art collective established since 1982 in downtown Toronto. The staff of thirty-nine is comprised of designers, reps and assistants, and the twenty-seven artists hail from Toronto, Vancouver, San Francisco, Berkeley, New York, New Jersey, Paris and London. Says partner and art rep, Bill Grigsby, "Reactor functions as a business agent for illustrators. Traditionally, reps have performed as commissioned sales agents, whereas Reactor works on a retainer basis. The retainer is equivalent to 25% of the illustrator's income. The artist receives a full package of services including management of invoicing, organizing tearsheets, soliciting assignments, promoting the artist's work and managing licensing agreements. Reactor provides office equipment, photocopier, other necessities and moral support."

The artists work in traditional and electronic media, and their work covers the stylistic spectrum from hyper-realism to expressionism, appearing regularly in major periodicals, book covers, posters and advertising campaigns in the United States, Canada, Europe and Japan. Their work is also found on postage stamps, packaging, murals and matchbooks. Original art is sold at Reactor's gallery/store on the premises.

The company maintains contacts with its buyers' network through go-sees and portfolio presentations, direct mail, incentive promotions, gallery shows and annual pages. Recently, Reactor booked multiple pages in *Workbook/Illustration* and *Creative Illustration*.

Reactor is known for a wide range of exciting material, including catalogs and announcements for exhibitions of their artists' work.

VICKI MORGAN

Vicki Morgan established Vicki Morgan Associates which, at various times, has represented photographers and designers in addition to illustrators. Currently, the firm works solely with editorial and advertising illustrators. Morgan is a member of The Society of Photographers and Artists Representatives, the Graphic Artists Guild and the Society of Illustrators.

How long have you been an artist's representative and how did you get into the business of illustration?
I've been a representative for almost twenty-five years. I got into it by way of being a fine art student. I was going to Cooper Union at night and working during the day at J. Walter Thompson. During that time I met a lot of illustrators, photographers and representatives. People recommended that I start my own repping business.

How did you get your talent at the beginning?
I decided to go with my strengths and the strengths of the industry at the time. Surrealism, cartoon and cross-hatch

were three very popular approaches. I started out with three illustrators. Today I have twelve.

What services do you offer your artists?
I do everything for them except the artwork. I usually am the one who designs their portfolios, with their approval, and I change it all the time. I collect the tearsheets and proofs, solicit business for them, write letters, send promotions, follow up, handle the calls that come in, negotiate, discuss not only the money, but also the artist's rights and what we're selling. I analyze contents and bring a legal understanding to the negotiations. I've established a lot of paperwork, such as estimates and confirmation forms and invoices that work.

If you rep someone who lives in California, can they have another rep in California?
If they want, and usually it means in the radius of their home area. If things are slow, they can always go out and see what they can do locally.

Does complete representation mean that you receive a commission on every single job that they do?
Each individual is different. If somebody comes to me with an established client, that client is not going to want me to participate. We might establish a 10% commission. They can deal with the client, but

Sample sheet from Vicki Morgan's promo kit. Illustrator: Kris Wiltse.

KRIS WILTSE

I want to do the billing. I want them to understand that I'm doing their business.

Do you buy pages in promotional directories and annuals?

Yes. I've been advertising in the *Showcase* for years. This year we're also advertising as a group in the *Workbook*. Not all my artists are in it. I said if you're going to be represented by me, you have to have an ad in the *Showcase*, and then after that, we can do whatever you want. This year we're in two different directories, and we're going into *Single Image*. I have a page with somebody in a European directory and we're in two pharmaceutical directories.

Aside from the directories, what other means of promotion do you do?

My own promotion has worked well for me. It's a 9×12 clear case with a button and my logo on one side. I put in all of the reprints from the directories as well as any other promotion that the artists have. I have a frontispiece, usually the same one that runs in the diretories announcing the Vicki Morgan section. The beauty is that it fits in an envelope. I put it in every portfolio that goes out. If somebody doesn't want it they leave it in. And it is a moveable feast of work, as opposed to a lot of the books that reps use which are stagnant.

How should an artist select a rep?

The symbiosis is really important. As a representative, I try to be more of a matchmaker, and I've often said I could never be a seller of something. I try to find the right artist for that call that the art director is placing to me.

What percentage of your clients are corporate, advertising, books, editorial, etc.?

My gut feeling is that we work in all those fields. I pursue all of them, and we pursue things like products, greeting cards— things that are out of the ordinary.

What percentage is your commission?

I charge 25% for jobs that are in New York City, 30% for jobs that are outside of New York and 30% percent on all jobs for people who live outside of the U.S. I started to do that some years ago because every-

Vicki Morgan's logo appears on all her artists' promotions, which may be printed in a variety of shapes and sizes which are then placed in a customized plastic envelope. Designer: Vicki Morgan.

Sample sheets from Vicki Morgan's promo kit. Illustrators: Left, Karen Blessen; right, Joyce Patti.

KAREN BLESSEN

JOYCE PATTI

body I represented lived out of town.

What makes a good relationship between a rep and an artist?

Trust. On both sides. I think I have to trust that I'm dealing with a professional and that when I say the job is due on Tuesday that I'm not going to get a call at nine o'clock on Monday night telling me it's not coming in. They, in turn, have to trust that the rep is a professional. You have to understand what your rep's system is and trust that they're being honest with your payments and that they are representing you honestly.

How do you know when an arrangement is not working out? Are there any signs?

Yes, just like in any relationship. If you begin to feel you're not trusting each other, if jobs come in that are continually not right, if the artist begins to question what the rep has said. You have to trust your instincts.

What thoughts do you have on pricing?

Sometimes fees seem arbitrary, and I

don't think they are. What I've done with my artists is talk about the fact that they need to earn X amount of money a year, and then we take it from there. I'm very big on trying to solve the problem.

How do you choose an artist to represent?

I'm looking for a business partner. I want somebody who says, "I have a good messenger service, a good attorney, a good accountant and I want an agent to handle that aspect of my business."

How has the business of illustration changed for you over the years?

I used to sit down on Mondays and make calls for the rest of the week. I'd see between three and ten people a day. It was one-on-one. It was nice because there was something personal about it. Today you don't see anybody because they have the directories. Most people aren't even in the town that the art directors are in, anyway.

What is it about the business of illustration that you enjoy?

Even though I'm not functioning as an artist myself, art is my life. My perception of the world is seen from the eyes of an artist. I'm involving myself in my business day with something that I feel good about.

THE PROS & CONS OF HAVING A REP

Pros:

- You have more time to concentrate on illustrating.

- The rep does all the negotiating for you, using years of experience in that area.

- You have the benefits of being part of a group with similar interests.

- You don't have to sell yourself, the rep does it for you.

- Since you often won't receive calls directly from the client, you have more time to consider accepting a job.

- The rep's contacts could lead to areas you might not have pursued on your own.

- As part of a group you could participate in promotional venues that you couldn't have afforded on your own.

Cons:

- You may lose contact with your clients.

- You give up 25% or more of your income.

- You risk being misrepresented in certain situations.

- You have to consider the rep's interests as well as your own when making any decisions.

- Depending on your assignment, you could find yourself compromising on the kinds of jobs you take.

- You may do samples for your portfolio that you're not interested in.

- There's no guarantee that a rep will bring you more income or better jobs than what you already have.

- As part of a group you might lose your identity.

Most experienced artists' reps will produce sophisticated promotional books, such as Bernstein & Andriulli and Renard Represents. Designer, left: Martin Pederson/Pederson Designs. Designer, right: Michael Schwab.

The area of pricing illustration is at best a murky one. In general, editorial fees are the lowest and offer the most creative freedom. Advertising ranks the highest, involving more direction and revisions. Corporate fees are often higher than publication fees. Stock usage of illustrations is increasing rapidly and second rights fees vary greatly. The area of pricing computer–generated art is also in its early stages and can be complex due to the amount of expenses incurred by the artist. Illustrators working on computer should discuss any additional expenses on top of the original fee with their clients and art directors, and receive approval before beginning a job. Following are some basic guidelines for pricing illustration. For more specific and detailed sources on pricing see *The Graphic Artists Guild Handbook of Pricing & Ethical Guidelines*.

CORPORATE & INSTITUTIONAL

ANNUAL REPORTS	Cover	Spread		Full Page		Half Page		Quarter Page		Spot	
		B&W	Color	B&W	Color	B&W	Color	B&W	Color	B&W	Color
Large circulation	$2,000–7,000	$1,500–4,500	$2,000–6,000	$1,000–3,500	$1,800–4,600	$750–2,500	$1,350–3,150	$600–1,900	$1,000–2,500	$250–1,250	$400–1,500
Medium circulation	$1,750–5,000	$1,000–3,500	$1,500–4,000	$1,200–3,000	$1,500–3,500	$800–2,000	$900–2,500	$550–1,500	$700–2,000	$200–1,000	$300–1,200
Small circulation	$1,000–3,750	$500–2,500	$800–3,000	$800–2,000	$1,200–3,750	$600–1,550	$800–2,000	$500–1,000	$600–1,200	$150–600	$250–800

HOUSE ORGANS	Cover	Spread		Full Page		Half Page		Quarter Page		Spot	
		B&W	Color	B&W	Color	B&W	Color	B&W	Color	B&W	Color
Large circulation	$1,000–6,000	$1,000–4,000	$1,750–4,500	$900–2,500	$1,500–3,500	$400–1,700	$750–2,500	$200–1,200	$400–1,500	$150–550	$300–900
Medium circulation	$800–3,500	$750–3,000	$1,500–4,000	$400–2,000	$900–2,800	$350–1,200	$500–1,500	$150–900	$250–1,200	$100–450	$250–600
Small circulation	$600–2,500	$500–2,000	$750–2,500	$300–1,250	$700–2,100	$250–1,000	$400–1,300	$150–775	$225–1,000	$100–450	$200–600

CONSUMER MAGAZINES

CONSUMER MAGAZINES	Cover	Spread	Full Page	Half Page		Quarter Page		Spot	
		B&W/Color	B&W/Color	B&W	Color	B&W	Color	B&W	Color
Large circulation	$2,000–4,000	$1,800–3,000	$1,000–2,500	$500–1,000	$600–1,500	$400–800	$500–900	$250–500	$350–700
Medium circulation	$1,500–2,500	$1,400–2,500	$800–2,000	$400–800	$500–1,200	$300–700	$400–800	$200–400	$250–600
Small circulation	$1,000–1,500	$1,000–1,500	$500–1,500	$300–700	$400–1,000	$200–500	$300–600	$125–350	$150–500

TRADE MAGAZINES

TRADE MAGAZINES	Cover	Spread	Full Page	Half Page		Quarter Page		Spot	
		B&W/Color	B&W/Color	B&W	Color	B&W	Color	B&W	Color
Large circulation	$1,500–3,000	$1,000–2,500	$750–1,500	$450–1,000	$500–1,200	$300–750	$400–900	$200–400	$350–750
Medium circulation	$1,000–2,000	$800–1,500	$600–1,000	$350–800	$400–900	$250–650	$350–800	$150–350	$250–650
Small circulation	$800–1,500	$600–1,000	$500–750	$300–600	$350–750	$200–600	$250–700	$125–300	$150–400

NEWSPAPERS

NEWSPAPERS	Section Cover		Spread		Full Page		Half Page		Quarter Page		Spot	
	B&W	Color	B&W	Color	B&W	Color	B&W	Color	B&W	Color	B&W	Color
Large circulation	$500–2,000	$750–3,000	$750–2,500	$900–2,750	$500–2,000	$800–2,500	$500–1,400	$500–1,750	$300–800	$400–1,000	$150–600	$250–750
Medium circulation	$300–1,500	$500–2,500	$450–2,000	$750–2,400	$300–1,500	$600–2,000	$300–1,000	$500–1,400	$200–700	$300–900	$150–500	$200–600
Small circulation	$200–1,000	$450–2,000	$350–1,500	$400–1,750	$200–1,000	$500–1,500	$200–800	$400–1,200	$150–600	$200–750	$100–400	$150–500

BOOKS

TRADE PAPERBACKS / TRADE HARDCOVERS

TRADE PAPERBACKS	Front Cover	Wraparound		TRADE HARDCOVERS	Front Cover	Wraparound
Large Distribution	$1,200–3,500	$2,000–5,000		Large Distribution	$1,400–4,000	$2,500–5,500
Medium Distribution	$1,000–3,000	$1,700–4,000		Medium Distribution	$1,200–3,000	$1,500–4,500
Small Distribution	$1,500–3,500	$2,000–5,500		Small Distribution	$1,600–4,000	$2,500–6,000

BOOK INTERIORS

BOOK INTERIORS	Spread		Full Page		Half Page		Quarter Page		Spot	
	B&W	Color	B&W	Color	B&W	Color	B&W	Color	B&W	Color
Large Distribution	$1,000–2,000	$1,500–3,000	$500–1,500	$1,000–2,500	$250–1800	$500–1,500	$200–600	$350–800	$150–500	$250–700
Small Distribution	$700–1,500	$1,000–2,500	$250–1,000	$750–1,750	$200–750	$400–900	$1500–500	$250–650	$150–400	$200–500

ADVERTISING

CONSUMER MAGAZINES	Spread		Full Page		Half Page		Quarter Page		Spot	
	B&W	Color	B&W	Color	B&W	Color	B&W	Color	B&W	Color
Large circulation	$3,000–8,000	$5,000–10,000	$2,000–6,000	$3,000–8,000	$1,500–4,000	$2,000–5,000	$1,000–3,000	$1,000–4,000	$600–1,800	$800–2,000
Medium circulation	$2,000–6,000	$3,000–8,000	$1,300–4,000	$2,000–5,000	$1,000–3,000	$1,500–4,000	$600–1,800	$1,000–2,500	$400–1,400	$500–1,500
Small circulation	$1,000–4,000	$2,000–5,000	$700–3,000	$1,400–4,000	$500–2,000	$1,000–3,000	$300–1,500	$500–2,000	$200–900	$300–1,200

TRADE MAGAZINES	Spread		Full Page		Half Page		Quarter Page		Spot	
	B&W	Color	B&W	Color	B&W	Color	B&W	Color	B&W	Color
Large circulation	$2,000–5,000	$3,000–8,000	$1,500–4,000	$2,000–5,000	$900–2,500	$1,500–4,000	$800–2,000	$1,000–2,500	$350–1,200	$500–1,500
Medium circulation	$800–4,000	$1,500–6,000	$1,000–3,000	$1,400–4,000	$600–2,000	$1,000–3,000	$600–1,500	$800–2,000	$300–1,000	$400–1,200
Small circulation	$400–1,000	$500–2,500	$700–2,000	$1,000–3,000	$500–1,500	$700–2,000	$400–1,000	$600–1,500	$250–750	$300–1,000

NEWSPAPERS	Spread		Full Page		Half Page		Quarter Page		Spot	
	B&W	Color	B&W	Color	B&W	Color	B&W	Color	B&W	Color
Large circulation	$2,000–5,000	$2,500–7,500	$1,500–4,000	$1,800–6000	$1,000–3,000	$1,500–3,500	$600–1,800	$1,000–2,500	$300–1,200	$500–2,000
Medium circulation	$1,500–3,500	$2,000–6,000	$1,000–2,500	$1,500–5,000	$750–1,500	$1,000–2,800	$350–1,000	$500–1,800	$200–800	$400–1,500
Small circulation	$1,000–2,500	$1,500–4,000	$600–2,000	$1,000–3,000	$500–1,200	$800–2,000	$200–800	$400–1,200	$150–500	$300–900

DIRECT MAIL	Cover	Spread		Full Page		Half Page		Quarter Page		Spot	
		B&W	Color	B&W	Color	B&W	Color	B&W	Color	B&W	Color
Large Printing	$2,000–7,000	$1,500–3,000	$1,800–5,000	$1,000–2,500	$1,500–4,000	$750–1,500	$1,000–3,000	$450–1,500	$750–2,000	$500–1,500	$750–2,000
Medium Printing	$1,500–4,000	$1,000–2,500	$1,500–4,000	$750–2,000	$1,000–3,000	$500–1,400	$750–2,200	$300–1,200	$500–1,500	$200–1,000	$300–1,200
Small Printing	$1,000–3,500	$700–2,000	$900–3,000	$350–1,500	$800–2,500	$300–1,000	$400–1,800	$150–800	$300–1,000	$100–500	$300–1,000

POINT OF PURCHASE	Large Piece		Medium Piece		Small Piece	
	B&W	Color	B&W	Color	B&W	Color
Large Printing	$1,500–4,000	$2,500–7,500	$1,200–3,500	$2,000–5,000	$1,000–2,500	$1,250–3,400
Medium Printing	$1,200–3,000	$1,500–4,500	$750–2,500	$1,000–3,500	$350–1,500	$750–2,500
Small Printing	$750–2,000	$1,000–2,500	$500–1,750	$750–1,500	$250–1,000	$500–2,000

ADVERTISING continued

TRANSIT	B&W	Color
Large Campaign	$2,000–4,000	$3,000–6,000
Medium Campaign	$1,500–3,000	$2,500–5,000
Small Campaign	$1,000–2,000	$1,500–3,000

BILLBOARDS	
Large Distribution	$2,500–7,000
Medium Distribution	$2,000–5,500
Small Distribution	$1,500–4,000

CHILDREN'S BOOKS

CHILDREN'S BOOKS	Advance	Royalty
Illustrations	$3,000–10,000	5%
Illustrations and Text	$4,000–15,000	10%

CD & CASSETTE COVERS

CDs & CASSETTES	Popular and Rock	Classical and Jazz	Other
Large Distribution	$1,200–7,000	$1,200–5,500	$1,000–3,000
Small Distribution	$1,000–4,000	$1,000–3,000	$900–2,500

MEDICAL

ADVERTISING

CONCEPTUAL	Spread	Full Page	Spot
Black and White Line	$1,800–5,000	$1,250–4,000	$450–1,000
Black and White Tone	$2,500–6,000	$1,800–4,250	$500–1,750
Color	$3,500–9,000	$2,250–7,500	$600–2,000

ANATOMICAL/SURGICAL	Spread	Full Page	Spot
Black and White Line	$1,350–1,800	$1,000–1,800	$350–750
Black and White Tone	$1,500–2,250	$1,250–2,200	$400–850
Color	$2,000–7,000	$1,750–5,000	$500–1,000

PRODUCT	Spread	Full Page	Spot
Black and White Line	$1,250–1,800	$1,500–2,000	$400–800
Black and White Tone	$1,750–3,000	$1,750–2,500	$450–900
Color	$2,500–7,000	$2,000–5,000	$500–1,000

EDITORIAL

PROFESSIONAL PUBLICATIONS AND MEDICAL JOURNALS

	Cover	Spread	Full Page	Quarter Page	Spot
Black and White Line	$500–750	$1,000–1,800	$750–1,500	$350–800	$300–600
Black and White Tone	$600–1,000	$1,250–2,000	$850–1,700	$400–900	$350–750
Color	$800–1,500	$1,000–2,000	$900–1,800	$500–1,000	$400–900

CONSUMER PUBLICATIONS/BOOKS & HEALTH AND SCIENCE MAGAZINES

	Cover	Spread	Full Page	Quarter Page	Spot
Black and White Line	$800–1,500	$1,250–2,500	$800–1,200	$250–750	$200–500
Black and White Tone	$1,000–2,000	$1,500–2,750	$950–1,500	$350–850	$250–550
Color	$1,200–2,500	$1,750–3,000	$1,000–1,800	$500–1,000	$300–600